FACING THE LATE VICTORIANS

PORTRAITS OF WRITERS AND ARTISTS

FROM THE MARK SAMUELS LASNER COLLECTION

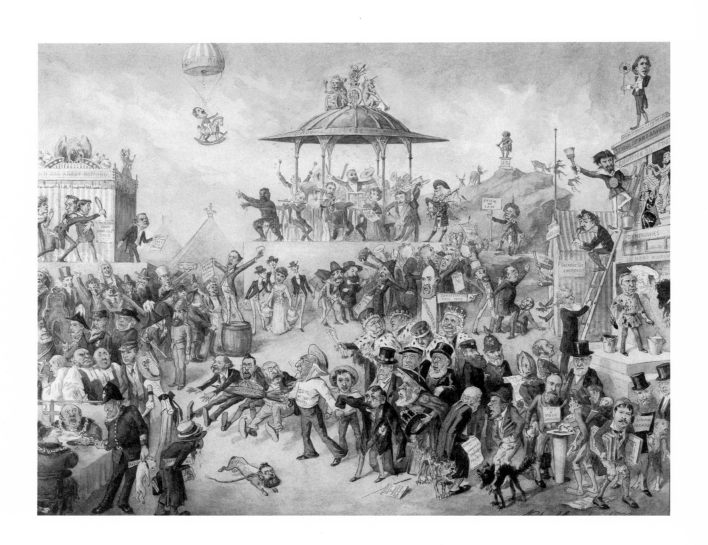

FACING THE LATE VICTORIANS

PORTRAITS OF WRITERS AND ARTISTS
FROM THE MARK SAMUELS LASNER COLLECTION

BY MARGARET D. STETZ

NEWARK · UNIVERSITY OF DELAWARE PRESS

2007

ISBN-10: 0-87413-992-9
ISBN-13: 978-0-87413-992-1

Associated University Presses
2010 Eastpark Boulevard
Cranbury, NJ 08512

The paper used in this publicaiton meets the requirements of the American National Standard for Permanence of Paper for Printed Library Materials, z39.48-1984.

Cataloging-in-Publication Data is on file with the Library of Congress.

Designed by Jerry Kelly

PRINTED IN THE UNITED STATES OF AMERICA

∽ PREFACE

This volume grows out of an exhibition, *Beyond Oscar Wilde*, held at the University of Delaware's University Gallery in autumn 2002. Curated by Margaret D. Stetz and using works in a variety of media from the Mark Samuels Lasner Collection of Victorian books, manuscripts, and works on paper, the exhibition focused on the complex cultural dynamics behind the surge of public interest in portraiture in late nineteenth-century Britain, especially in portraits of writers and artists. One of the focal points of that show was Oscar Wilde (1854–1900), who remains central to this volume. Wilde appears throughout as a subject and interpreter of portraiture and as the figure who best understood how to exploit both the commercial and social possibilities of the modern age of celebrity, which was ushered in by the fascination with individual faces.

If the second half of the nineteenth century in Britain was the new age of the mass—of mass production, mass marketing, and mass culture—it was by no coincidence also the time when a new cult of individuality arose. To distinguish oneself from others and, simultaneously, to study those who had distinguished their own lives, careers, and especially their appearances became a widespread preoccupation. We may think now of the late Victorians as all alike: as a blur of dark clothing from chin to toes in the case of men, or from bosom to ankles in the case of women, and of heads obscured by seemingly identical hats. But they saw one another quite differently, reading in the cut of a dress or in the styling of a tie, for instance, a range of gradations in class, aesthetic taste, and even political sympathies, all indicating the particular combination of self-conscious choices and imposed social constraints that made up the wearer's identity.

At the end of the nineteenth century, new theories of psychology, centering upon physiognomy as a guide to character, encouraged women and men to appraise faces with keen interest and to compose their own expressions in ways that would send a desired message. In an age, too, when the printed advertisement reigned supreme, the individual face became a form of visual promotional literature, selling to spectators the idea of its bearer as a figure of importance. (Fittingly, the frontispiece in this volume is an advertisement that uses a range of "important" faces to sell a commodity and, in the process, also turns those faces into important commodities.) Marketing of the self was particularly necessary in the case of writers and artists, who wished to be seen as persons of genius and thus who had to cultivate the appearance of genius—a surface look suggesting that there was a creative spark lighting the face from within. They were aided in this, of course, by the huge numbers of professionals whose careers were dedicated to generating or disseminating the human image: photographers, printers, engravers, gallery owners, portrait painters, and publishers. The worlds of High Art (with a capital "A") and of print culture worked together well in this process of production, reproduction, and circulation.

This volume provides a wide representation of both major and minor figures in late Victorian literary and visual culture, offering access to many rarely seen images of and by British artists. In

doing so, it also opens up to academic specialists and to general audiences alike a glimpse of the riches of the Mark Samuels Lasner Collection, which has been assembled over the past thirty years by one of the premier authorities on nineteenth-century book history. That collection of first editions, presentation copies, authors' correspondence, and works of art and design is currently housed at the University of Delaware's Morris Library, where scholars are now able to make use of this unique store of materials. Since its opening in spring 2005 with an event at which, quite appropriately, the grandson of Oscar Wilde, Merlin Holland, served as keynote speaker, the Mark Samuels Lasner Collection has become a vital resource that complements the impressive holdings in late Victorian manuscripts and books of the University of Delaware Library's Special Collections Department.

ℰ ACKNOWLEDGMENTS

WARMEST THANKS go to President David Roselle and Provost Daniel Rich of the University of Delaware for vision, leadership, and generous championing of the arts. Many thanks also go to Mae and Robert Carter. The exhibition at the University Gallery that inspired this volume relied upon the outstanding talents of Belena Chapp and Janet Broske, with assistance from Tim Goecke. It was supported in numerous ways by Kevin G. McCullen, Mark Huddleston, Marian Lief Palley, and Jerry Beasley. Thanks for unstinting professional assistance in preparing this volume also go to Donald Mell of the University of Delaware Press; to Julien Yoseloff of the Associated University Presses; to Debra H. Norris and the UD Art Conservation Department; to Margaretta Frederick of the Delaware Art Museum; to J. Fernando Pena of the Grolier Club; to George Dalziel, Jr. of the Library of the National Gallery of Art; and to Jodi Devine, Gerald Cloud, and Rae Russell. I thank Rick Echelmeyer for his superb photography and Jerry Kelly for his brilliant design. But nothing would have been possible without the extraordinary efforts of Susan Brynteson, Director of Libraries at the University of Delaware, to whom I dedicate this book with deepest gratitude.

Many thanks to the following for permission to reproduce copyrighted works: Henry Lessore and DACS: estate of Walter Sickert (Walter Sickert's *Self-Portrait*); Leonie Sturge-Moore and Charmian O'Neil for work by Charles Haslewood Shannon; A. P. Watt Ltd on behalf of the National Trust for Places of Historic Interest or Natural Beauty and the estate of Rudyard Kipling (Rudyard Kipling's *Self-Portrait*); Bridgeman Art Library International and the estates of Augustus John and of Sir William Rothenstein for work by John and by Rothenstein; Christian du Maurier Browning and The Chichester Partnership for work by George Du Maurier; Berlin Associates and the estate of Sir Max Beerbohm for work by Sir Max Beerbohm.

✌ INTRODUCTION

I N 1842, Alfred Tennyson used his poem "Break, Break, Break," with its forcefully repetitive title, to express the monotony and emptiness of grief. To mourn for someone, as he wrote then, was to long for a kind of sensuous contact no longer possible: "But O for the touch of a vanish'd hand,/And the sound of a voice that is still!" What seemed to the early Victorian poet most real about the beloved dead—and so, what was most deeply missed—was the memory of what one had grasped or heard: the feel of their flesh, the tone of their speech. Touch and sound encapsulated for readers, too, of the early 1840s the reality of human existence and constituted the essence of individual personality.

By 1889, Tennyson—who was now Lord Tennyson and had been, since 1850, Britain's poet laureate—no longer thought only of others' deaths, but contemplated his own. At the age of eighty, he published the poem "Crossing the Bar." There, he looked forward with trepidation, but also with an optimism produced by faith, to what he imagined as the last and greatest adventure—his encounter with the God who had steered his destiny: "I hope to see my Pilot face to face/ When I have crossed the bar."

Face to face. What an extraordinary notion!—or rather, how extraordinary for Tennyson to hold two such notions. For the line hung not merely upon the poet's belief that the Deity would prove to have a face, but upon his reliance on the continued existence, even in the afterlife, of a human face for the Pilot to confront. Thus, the closing image assumed that the speaker's own face, too, was immortal. The climactic moment of revelation would come with these two individual faces looking at one another. Touch, sound—these would be unimportant. Sight would supplant them. Indeed, it already had supplanted them in late Victorian culture and, as a consequence, the face had usurped both the hand and the voice as the core marker of being.

Tennyson should be forgiven the rather immodest fancy of supposing that his face would prove immortal for, by the late 1880s, it already was. Portrait artists had made it so. By the end of the century, visual representations of him had been entering the collective consciousness of the British public for more than a generation and had impressed upon the laureate himself the importance of his own face, as well as the likelihood of it outlasting his death.

There were new Tennyson portraits in every decade. Samuel Laurence had shown Tennyson as a sensitive soul in an oil dating from around 1840. D. G. Rossetti had sketched him in restless action, reading "Maud" in 1855, around the same time that Richard Doyle, known as the illustrator of Thackeray's fiction, had drawn him looking pensive and somber. A Manchester photographer, James Mudd, is thought to have been the one who photographed him in the early 1860s as a subject glancing rather suspiciously at the camera. G. F. Watts had made him Christlike in an 1859 oil, with a face haunted by suffering, then meditative and melancholy in another oil from the mid-1860s.

But it was the work of Tennyson's friend and neighbor, Julia Margaret Cameron, that turned his face into an iconic embodiment of literary genius. In Cameron's photographs of the mid-1860s, especially *The Dirty Monk*, Tennyson inhabited the role not only of the poet laureate, but of the quintes-

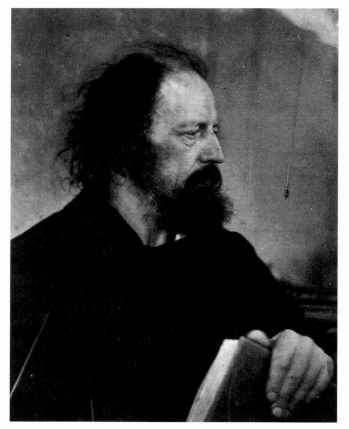

sential Victorian Poet (a status deserving of capitals): a figure with a furrowed brow, hawklike profile, wind-tossed hair and beard—signaling a mind too preoccupied with weighty thoughts to concern itself with brushes or even soap—cloak thrown theatrically around the shoulders, and book in hand. Cameron's photographic methods, which involved "uncomfortably long exposures," required "serious and even painful commitment from her sitters."[1] That Tennyson would have subjected himself to such discomfort indicates the depth not merely of his friendship with Cameron, but of his own interest in seeing his image satisfactorily recorded for posterity.

In later years and in later portraits of Tennyson, various props would come and go. The *Vanity Fair* magazine caricaturist Ape (i.e., Carlo Pellegrini) would show Tennyson's massively intellectual head set off by an equally massive top hat, along with both spectacles and a monocle. (An all-seeing poet would presumably need the distance and the close-up lenses, in order to be all-seeing.) In an 1888 photograph by William Barraud, Tennyson would be seated, the omnipresent book balanced on his knees, and a wide-brimmed hat of bohemian shape shadowing his gaunt face with its hollow cheeks and deep, suspicious eyes—a rather intimidating representation of the laureate as a lean, mean, writing machine. Walter Crane's 1882 image of him in the group caricature for the frontispiece of *Living English Poets* (reproduced in this volume) may have characterized Tennyson as indubitably English, but perhaps as less clearly among the living. Instead, draped in a cloak, Tennyson seemed more like a monumental piece of statuary built for the ages than a mere man of flesh and blood.

Charles Lucy's portrait of Tennyson (reproduced in this volume) is, in comparison with these many book-wielding, cape-sporting, hat-wearing figures, a rather spare and sober image. Yet it is also a formal one that emphasizes the gravity of the sitter and gives the spectator a view only of what we might call Tennyson's public face. (It is, for instance, unlike the more intimate, revelatory watercolor—also reproduced in this volume—that Helen Allingham made of her husband, the poet William Allingham, which records the private, unguarded face he wore in their domestic relations.)

Lest we suppose that Tennyson was too unworldly and high-minded to notice or care about the details of these many portraits of himself, we have his response to John Everett Millais's oil, in which the Bard gazes piercingly at the viewer, his head brightly lit above his massive black cape. The paint-

ing was commissioned in 1881 by the Fine Art Society to hang there as part of its Millais show, no doubt on the grounds that the public would expect any exhibition by a major portraitist to include the head of the Queen's favorite bard. Tennyson put himself at Millais's disposal through seven sittings which stretched over a two-month period. Millais himself felt that this was "the finest portrait he had ever painted."[2] Yet of the image resulting from these labors, Tennyson said disgustedly and dismissively, "It has neither a brain nor a soul, and I have both."[3] Clearly, Millais's vision of the poet did not sufficiently resemble the face that Tennyson planned to bring along with him to meet his Pilot. On the other hand, it pleased others—so much so, that the Fine Art Society published and distributed it as a mezzotint.

That was one way in which images of faces circulated throughout the late Victorian world. As Dennis Denisoff reports, "During the second half of the nineteenth century, portraiture was among the most lucrative artistic activities."[4] Sophisticated Londoners' taste for gallery-hopping as an upper-middle-class urbanites' recreation and for owning reproductions of works which had created a stir meant that fresh supplies of heads were, rather ghoulishly, in constant demand by gallery visitors and by would-be purchasers. Salome, the protagonist of Oscar Wilde's 1893 play, wanted only one head served up to her; Wilde's contemporaries proved far greedier.

Professional portraitists were valued highly in the London art world and in social life in general. They were sought out not merely by fellow visual or literary artists—sitters who rapidly grasped the potential for the representation and display of their images to increase their own public recognition as geniuses—but by everyone able to afford their services. In her episodic comic novel of 1892, titled *My Flirtations* and issued under the pseudonym of Margaret Wynman, Ella Hepworth Dixon would have her female narrator comment tartly upon this situation:

> *A great many people come to our house, and they have always done so as long as I can recollect. Father is a Royal Academician, and paints shocking bad portraits, but the British public is quite unaware of the fact. The British public likes to be painted by a Royal Academician, so it pays large prices and is hung on the line in the big room at Burlington House. They all come; red-faced, red-coated M. F. H.'s [i. e., Masters of Foxhounds], the bejewelled wives of Manchester millionaires, young beauties, heads of colleges, the celebrities of the day—they all sit, with the same fixed eyes and the same tight smile, on the daïs in our gorgeous studio.*[5]

Even as these visions of the individual face were being commissioned for public exhibition, many images were being made for private consumption. The perception shared by the majority of late Victorians that the world was a fast-moving place, wired (as we might say now) by means of the telegraph and the telephone, and that time itself was short, speeding by on the new electric trams and underground trains, fueled the urge to preserve the moment and so to record the human face before it aged and altered. Whether in studios or in domestic settings, women as well as men sketched or painted one another's likenesses.

Feminist agitation throughout the second half of the century had won for middle- and upper-middle-class women wider opportunities not only for higher education, but for art training comparable to that available to men. This was especially true after 1871 with the founding of London's Slade School, which led the way in instructing women and which, by the 1890s, even opened to them

life-classes where nudes were drawn. As a young and unmarried lady, the writer Ella Hepworth Dixon, who came from a progressive family (her father, William Hepworth Dixon, was editor of the *Athenaeum* and her Irish-born mother was an early supporter of women's suffrage), was allowed to study painting in Paris. Decades later, in her 1930 memoir *As I Knew Them*, Dixon would describe a domestic scene from 1880s London life that revolved around a feminine circle of amateur portraitists, working communally:

> *The first time Oscar Wilde loomed on my horizon I was painting, together with Charlotte McCarthy and my sister, a portrait of Justin McCarthy the younger, in their hospitable house in Bloomsbury. Our model had got himself up in mediaeval finery and we had chalked in our outlines, when an announcement came, somewhat pontifically, from a tall, stout young man, leaning with his back to the window. . . . The voice of the young man in the window was remarkable; I am sure now it was one of Oscar Wilde's principal assets.*[6]

It is fitting that Oscar Wilde should have been part of this *tableau*, for he proved the most famous and infamous example of someone who turned seemingly unpromising physical features into yet another remarkable asset and then, so to speak, into "principal," by exploiting the late Victorian hunger for the circulation of portraits. His interest in the subject was no accident. At the age of twenty-one—as his grandson, Merlin Holland, notes in *The Wilde Album*, a 1997 picto-biography—Oscar Wilde began a close relationship "with a young portrait painter living in London, Frank Miles. . . . Miles was already well introduced into London society through his sketching or painting of the great and the beautiful, and it was in his studio that Wilde first met Lillie Langtry."[7]

Langtry, of course, became an icon of beauty in Britain and America through the mass distribution of photographic portraits that constructed her, with her severely Classical dress and "Greek" profile, as the modern Helen of Troy. Through his observations of these two new friends, Miles and Langtry, and their flourishing careers, Wilde learned the power not only of painting, but even more of photography, as indispensable to achieving his twin goals of fame and financial reward. Despite the "great promise of photography," as Elizabeth Wilson has said, that it "would tell the 'truth'" about its subjects, the photograph offered limitless possibilities for the enhancement and manipulation of imagery; "the 'truth' of photography" proved to be "only a more convincing illusion, selection and artifice lurking behind the seeming impartiality of the mechanical eye."[8] In Oscar Wilde's lifetime, the photograph increasingly eclipsed other forms of visual representation of faces, bodies, and costume, largely because it suited so well the interests of the burgeoning periodical press. Shelton Waldrep has suggested that

> *Wilde's development of an identifiable public personality—whether given to him, as it was by Gilbert and Sullivan and the illustrators of* Punch, *or one of his own design—was possible only as the technical means for the reproduction of his type became available. Wilde's concept of his own creation as a type, in other words, could only have the influence it did through the various forms of rapid reproduction of the time such as photography, journalism, and publishing. . . . Indeed, Wilde was amazingly adept at using the system of promotion through technology to imprint versions of his personality—or type—to distribute as many ways as he could.*[9]

As the century wore on, art galleries were not the chief way in which images reached mass audiences, especially audiences outside of London. Most portraits, whether in pen and ink, in oils, in

watercolor, or in the photographic medium were seen by and known to the public through magazines and newspapers. After 1880, half-tones and line blocks began to replace wood engravings, which meant that photographs (including photographs of works of art) could be reproduced easily and cheaply. This development increased greatly the number of portraits in general in the periodical press, as well as those representing writers and artists in particular. Technology not only fed the desire to gaze upon faces, but created that desire. Print culture demanded the sight of human subjects.

More and more periodicals sprang up to cater to the taste for visual matter. In his *Dictionary of British Book Illustrators and Caricaturists, 1800–1914*, Simon Houfe tried to give twentieth-century readers a notion of the astonishing range of magazines available to an educated public at the fin de siècle—some for short runs, some for longer ones, but all of them using illustrations. These included the *English Illustrated Magazine*, the *Strand*, the *Pall Mall*, the *Pall Mall Budget*, the *Sketch*, the *Pick-Me-Up*, the *Graphic*, the *Hobby Horse*, the *Dial*, the *Butterfly*, the *Studio*, the *Yellow Book*, the *Savoy*, the *Quest*, the *Quarto*, the *Page*, the *Beam*, the *Dome*, the *Echo*, the *Black and White*, and the *Idler*.[10] That list is by no means complete. There was, in other words, a vast market for pictures and a large number of outlets competing for pictures. Of those pictures, a great many were portraits.

A multitude of faces looked out at the spectator every day from the pages of the periodical press. Often, these images accompanied articles about writers or about artists, too, as well as conversations with such figures. The late Victorian industy known as the New Journalism had discovered the marketability of personality. In the process, it created the modern notion of the celebrity, the figure known for being known. Journalists produced portraits in words of the chosen individual, while printers reproduced photographic images of his or her face, and the total package gave the person featured in magazines and newspapers a kind of star power. "Stylistically," as Barbara Onslow notes, the New Journalism was "characterized by its emphasis on 'human interest,' what [T. P.] O'Connor called its 'more personal tone,' and the narrative format of 'the interview.'"[11] The subjects of these journalistic studies included numerous writers or artists, and the end of the nineteenth century saw the emergence of magazines dedicated almost exclusively to publishing profiles of them.

Missing from Simon Houfe's list above of illustrated periodicals was, for instance, the *Bookman*, established in 1891 by William Robertson Nicoll, a "popularizer of literature."[12] Nicoll's monthly specialized in biographical copy about writers, alongside reviews of current books and professional advice to those hoping to sell their works to publishers. The magazine's first issue contained no pictures of the people discussed. By the second issue in November 1891, however, readers found an article titled "Brontë Portraits" which reproduced four different images of members of the Brontë family circle. The next month, a purchaser's sixpence bought not merely text, but a full-page inserted plate with black-and-white photographic reproductions of the pinup-like portraits of two pretty faces—the heads of the contemporary writers Mary E. Wilkins (later Freeman) and Sara Jeanette Duncan.

In the mid-1890s, when H. G. Wells wanted to satirize modern poets, he started a tale called "In the Modern Vein: an Unsympathetic Love Story" (first published as "A Bardlet's Romance" in the 8 March 1894 issue of *Truth*) with a devastating description of an imaginary figure—self-absorbed, arrogant, and unreliable— named "Aubrey Vair." This creator of "volumes of delicate verse" was

familiar to the public not so much through his poetry, but chiefly because his "Byronic visage and an interview" had appeared in a lady's magazine.[13] Wells's somewhat mean-spirited literary caricature of this contemporary type, who lives to get his picture in the papers, bears an uncanny resemblance to a real-life contemporary, Richard Le Gallienne. (Max Beerbohm's own visual caricature of Le Gallienne is reproduced in this volume, showing a figure whose Shelleyan hair is so luxuriant that it seems to have sprouted skylark wings and geared up to take flight.) It is tempting to find in Wells's comic assault upon Le Gallienne, the more photogenic writer, an instance of sour grapes. Wells's unprepossessing appearance meant that he was conscious of having entered the new visually oriented marketplace, where fetching portraits alone could sell books, at a material disadvantage.

At the same time that portraits increasingly dominated mass culture through the circulation of reproductions in periodicals, they were also acquiring a new status and significance in the world of high culture. In 1859, the National Portrait Gallery opened in its first location, at 29 Great George Street, Westminster. Before its founding, it had been discussed in the House of Commons and proposed as a "Gallery of the Portraits of the most eminent Persons in British History," thus tying together images of faces with ideas of national pride and political identity. During Parliamentary debates over the proposal, Lord Palmerston had concluded that

> There cannot, I feel convinced, be a greater incentive to mental exertion, to noble actions, to good conduct on the part of the living, than for them to see before them the features of those who have done things which are worthy of our admiration, and whose example we are more induced to imitate when they are brought before us in the visible and tangible shape of portraits.[14]

Looking at portraits, as Lord Palmerston told his Victorian contemporaries, was instructive and uplifting. There was something to be learned from the features of those who had accomplished significant achievements; the distinction of their minds and spirits would be written on their faces, and viewers would be moved to self-improvement by contemplating their expressions.

But the ability of the spectator to distinguish these admirable qualities in a face depended upon special training. Just as we take for granted now the importance of being computer-literate, so the late Victorians believed in becoming portrait-literate. Even if you could not paint a portrait or take a photograph that emphasized character and made the essence of personality visible, you could still develop skill in reading correctly the images created by others. How might you do that? By immersing yourself in late Victorian literature. Whether we turn to nineteenth-century British poetry, drama, fiction, essays, or non-fiction prose, portraits are everywhere, and so are figures commenting upon the features of the subjects, acting as guides for readers in the uncharted territory of face-interpretation.

Every aspect of late Victorian society was gendered and hierarchized and so were facial features, which were anxiously scrutinized first for masculine or feminine characteristics, as well as for those indicating class. Indications of masculinity and femininity were often described as present in images of both men and women. The "consensus," for example, of "contemporary opinion about George Eliot's appearance," as Rosemary Ashton notes, was that it seemed "mannish";[15] viewers reported finding evidence of this mannishness in her portraits as well. While a hint of cross-gendered qualities was permissible—particularly in the faces of female geniuses such as Eliot, whose talent could

only be accounted for by the possession of a partly "masculine" temperament—the supposed predominance of these usually signaled something problematic or distasteful about the subject. Fiction writers used this assumption as a helpful shorthand, even as they trained audiences in the reading of gender through faces. George Gissing, for insistence, knew that he could alert his audience early to the potential for the selfish, imperious, and even heartless behavior that his character Amy Reardon would display later in *New Grub Street* (1891) by introducing the hero's wife as the owner of unwomanly features which had little propensity for a feminine blush:

> *Yet the face was not of distinctly feminine type; with short hair and appropriate clothing, she would have passed unquestioned as a handsome boy of seventeen, a spirited boy too, and one much in the habit of giving orders to inferiors. . . . The atmosphere was cold; ruddiness would have been quite out of place on her cheeks, and a flush must have been the rarest thing there.*[16]

Around the same time, Thomas Hardy could signal to readers of *Jude the Obscure* (1896) that his protagonist was, as an interpreter of human character, dangerously naïve, by having Jude study a portrait of Sue Bridehead and recognize none of the ambiguity of this ambiguously gendered New Woman. Poor, unsophisticated Jude could see nothing more in it than "the photograph of a pretty girlish face."[17]

The activity of reading faces was an equal-opportunity occupation. Men interpreted portraits of men; men interpreted portraits of women. Women produced readings of men's portraits; women produced readings of portraits of other women. Perhaps the most famous literary example of a man explicating a contemporary portrait of a male face came, appropriately enough, from Oscar Wilde, who was on the cutting edge in exploiting the late-nineteenth-century craze for portraiture. After all, he had advanced his own career tremendously in the early 1880s, during his lecture tour of the United States, by visiting the studio of photographer Napoleon Sarony and having some twenty-seven different portraits taken of himself. These he had circulated to the press in New York and in London. The image of Wilde as a languorous aesthete wearing a kinky combo of velvet, silk, and fur, his long hair flowing around his fleshy cheeks and heavy-lidded eyes, had made him notorious. More important, though, it had brought him notoriety far beyond anything he could have attained so quickly through writing alone. Wilde grasped the potential of the new publicity industry to manufacture the product he wanted for himself: celebrity. As his portraits made their way into print on both sides of the Atlantic, they inspired commentary, caricatures, cartoons by the likes of George Du Maurier in *Punch*, and also piracies, especially for the purpose of advertising. (See, for instance, one of these unauthorized commercial uses of Wilde's image in the present volume, with the sheet music for the *Oscar Wilde Galop*.)

So Wilde may be forgiven for thinking back upon the progress of his own career, from the vantage point of several years after his photographic collaboration with Sarony, and for creating a fantasy upon the idea of portraits as having, quite literally, lives of their own, beyond the control either of their makers or of their subjects. In scene upon scene of *The Picture of Dorian Gray*, the eternally lovely youth, Dorian, returns from his wicked escapades to scrutinize the portrait of himself and to discover the evidence of his bad behavior registered on the face in the painting:

In the dim arrested light . . . the face appeared to him to be a little changed. The expression looked different. One would have said that there was a touch of cruelty in the mouth. . . . He rubbed his eyes, and came close to the picture, and examined it again. There were no signs of any change when he looked into the actual painting, and yet there was no doubt that the whole expression had altered. It was not a mere fancy of his own. The thing was horribly apparent.[18]

Such scenes, of course, turned out to be uncannily prophetic of what would happen after April 1895, when Wilde was brought up on charges of committing acts of "gross indecency" with men. Following Wilde's arrest, conviction, and imprisonment, homophobic late Victorian contemporaries would look again at the numerous images of his face in circulation and recoil from these with loathing, insisting that they could see the evidence of immorality in his features. Some, in fact, said that they had been able to do this even before the revelations of the Wilde trials. That, for instance, was what the California-born expatriate novelist, Gertrude Atherton, later claimed in her memoir, *Adventures of a Novelist* (1932). There, she asserted that she had been given the opportunity in the late 1880s to meet Oscar Wilde in London, at his mother's house, but had decided to refuse after coming upon his portrait:

But a day or two later I saw a photograph of him. His mouth covered half of his face, the most lascivious coarse repulsive mouth I had ever seen. I might stand it in a large crowded drawing-room, but not in a parlor eight-by-eight lit by three tallow candles. I should feel as if I were under the sea pursued by some bloated monster of the deep, and have nightmares for a week thereafter. I sent a telegram to Lady Wilde regretting that I was in bed with a cold.[19]

After the spring of 1895, Wilde's sympathizers and supporters, too, would reinterpret his face retrospectively and by doing so attempt to soften the public's attitude toward him. At the same time, they would try to teach audiences a less censorious way to read portraits in general, one that emphasized biological determinism as much as moral significance. Ella D'Arcy (whose own *Yellow Book* portrait appears in this volume) published a story titled "The Death Mask" in the July 1896 issue of the *Yellow Book*, one of the most important of the late Victorian illustrated magazines and, by no coincidence, a production of the same firm that had issued Wilde's books. D'Arcy's story had no plot or action. It consisted of nothing but the thoughts of a nameless male narrator who is shown the plaster cast of the head of an artist-figure, a genius who has just died. The narrator looks at the features of the late genius under two different lights. The first time, he sees a monster: "a face so unutterably repulsive, so hideously bestial, that I grew cold to the roots of my hair."[20] But then, once the position of the lamp behind it is altered,

The astounding way the face changed must have been seen to be believed in. It was exactly as though, by some cunning sleight of hand, the mask of a god had been substituted for that of a satyr. . . . [ellipses in original] You saw a splendid dome-like head, Shakespearean in contour. . . . The lips no longer looked gross, and they closed together in a beautiful, sinuous line. . . . You discerned the presence of those higher qualities which might have rendered him an ascetic or a saint; which led him to understand the beauty of self-denial, to appreciate the wisdom of self-restraint.[21]

Portraits, in other words, could hold multiple, even antithetical, meanings, just as the human character might prove complex, multi-sided, and (as Robert Louis Stevenson's Dr. Jekyll had suggested a

decade earlier, while studying the reflection of his own changing face in a cheval-glass) capable of divergent possibilities that might emerge under different social and environmental conditions.

Of course, all such literary scenes that involved the "reading" of representations of faces had a vaguely familiar quality to late Victorian audiences, for almost all fell into rhythms that echoed the most famous example, from Walter Pater's 1873 *Studies in the History of the Renaissance*. For that assemblage of essays, Pater (whose own image appears in the present volume) composed a rhapsodic interpretation of Leonardo da Vinci's *La Gioconda*, the Mona Lisa. In Pater's hands, Leonardo's portrait of her became an image which, if read correctly by an aesthetic critic, would reveal the whole course of civilization and culture in the West,

> *expressive of what in the ways of a thousand years men had come to desire. Hers is the head upon which all 'the ends of the world are come,' and the eyelids are a little weary. It is a beauty wrought out from within upon the flesh, the deposit, little cell by cell, of strange thoughts and fantastic reveries and exquisite passions. . . . All the thoughts and experience of the world have etched and moulded there, in that which they have of power to refine and make expressive the outward form, the animalism of Greece, the lust of Rome, the reverie of the middle age. . . . Certainly Lady Lisa might stand as the embodiment of the old fancy, the symbol of the modern idea.*[22]

Again and again throughout the late Victorian period, we find writers and artists alike making similar links between the concept of modernity and representations of women's heads. In everything from high culture to the world of advertising, the image of the modern age was the face of a woman, especially of the so-called New Woman—a figure associated with rebellion, autonomy, the assertion of individual rights, dissatisfaction with the world as it was, and the breaking up of the conventional social order, though particularly of gender hierarchies. Both men and women drew this modern woman, painted and photographed her, and wrote about the face that she wore in public and in private. They found her particularly emblematic of the modern when the New Woman was a writer or artist herself.

Sarah Grand (Frances Clarke McFall) made the male protagonist of her fin-de-siècle short story "The Undefinable: A Fantasia" a professional portraitist specializing in society figures. His work descends into dullness and irrelevancy, until he is visited one day by a Muse from ancient Greece in the form of a New Woman-ish model. This model, who wears up-to-date costume and whose face is alive with "fearless candour" and "insolence," opens up to him a vision of modernity through her embodiment of "the glorious womanhood of this age of enlightenment, compared with the creature as she existed merely for man's use and pleasure of old."[23] Brought to a moment of epiphany by her uncategorizable appearance, the painter says, "I recognized her now—a free woman, a new creature, a source of inspiration the like of which no man hitherto has even imagined in art or literature." Acknowledging her arrival, her bold appropriation of his studio for an artistic *tableau* of her own, and her sudden disappearance as "a kind of allegory," he dedicates himself to capturing her spirit in his future portraits.[24]

When the essayist Laura Marholm Hansson wanted to summon up through words the temper of the modern age, she turned in the mid-1890s to describing the face of Mary Chavelita Dunne, a New

Woman who began her career as a short-story writer in 1893 under the pseudonym of George Egerton. Hansson's lengthy and probing meditation upon a pair of photographs of this Irish author made sense only in a climate where the reader could be counted upon to share her fascination with individual physionomical details as signifiers—not merely of individual psychology, but of universal shifts in cultural evolution that were embodied in women's appearances:

> *I have before me a new book by Mrs. Egerton, and two new photographs. In the one she is sitting curled up in a chair, reading peacefully. She has a delicate, rather sharp-featured profile, with a long, somewhat prominent chin, that gives one an idea of yearning. The other is a full-length portrait. A slender, girlish figure with . . . a tired, worn face, without youth and full of disillusion; the hair looks as though restless fingers had been passed through it; and there is a bitter, hopeless expression about the lines of the mouth. . . . She is a type of the modern woman, whose inmost being is the essence of disillusion.*[25]

A photograph of George Egerton from this same period of the mid-1890s appears in the present volume. We might wonder why there were so many images of this particular New Woman writer circulating at the time. Her name only recently had become known with the publication in December 1893 of her book of short stories, *Keynotes*. Yet depictions of her seemed to pop up everywhere: in photographs accompanying an interview in the magazine the *Sketch*; in caricatures based on her in *Punch* and in Albert Morrow's theatrical poster for Sydney Grundy's 1894 satire, *The New Woman*; in a reproduction of a watercolor portrait by E. A. Walton in the April 1895 issue of the *Yellow Book*, etc. To explain how this turn-of-the-century equivalent of a media blitz featuring George Egerton's face occurred, we must appreciate not only the new role that late Victorian journalists and editors were playing in creating celebrity culture, but also the effect of intervention by publishing firms, which increasingly involved themselves in the marketing of books and also of authors as commodities.

Traditionally, nineteenth-century publishers had been rather discreet and low-key in their role as booksellers. Publishers of fiction, in particular, had been able to count upon unloading large numbers of books, with very little effort, through the circulating libraries. Up until the mid-1890s, most novels were published in three volumes, then lent one volume at a time by subscription libraries such as Mudie's, for books remained too costly even for middle-class readers to buy outright. But by the end of the century, new technologies, which had made the reproduction of images possible, had also made papermaking, printing, and binding cheaper. As books became affordable, they could be offered directly to consumers by the publishers through bookshops and railway stalls.

The challenge, then, was how to attract and entice casual browsers and turn them into purchasers. With so many titles competing for attention, selling the author as a figure of interest became the modern strategy (a strategy still in place today). One way to make bookbuyers feel personally connected to the writer was through portraits, which could quite literally put a face to an otherwise unknown author and manufacture a sense of relationship between the consumer and the creator of the text.[26] The present volume demonstrates how, for instance, Olive Schreiner's 1891 *Dreams*, a collection of short prose works by another New Woman, was marketed through its use of a rather glamorous photograph of Schreiner as the frontispiece. Publishers laboring on behalf of writers such as

George Egerton—in this case, the important London firm known as the Bodley Head, run by the very market-savvy and aggressive bookseller, John Lane—pressured authors to have themselves photographed or painted and then used the resulting images to engineer publicity campaigns.

But there was one difficulty. Publishers might hope to decide where representations of their authors would appear; writers might wish to oversee how their images were used; portrait artists, too, might desire to keep some rein upon the circulation of their creations and to profit from their reproduction. Until the the end of the century, however, copyright law—especially international copyright agreements between Britain and the U.S.—tended to be vague at best and non-existent at worst. Such law, moreover, was very seldom enforced anywhere. Unlicensed reproductions abounded and were employed for many different purposes. Oscar Wilde was merely stating fact, not creating fantasy, in *The Picture of Dorian Gray*, when he wrote about the painted image of a face seeming to have an autonomous life cycle, changing and evolving on its own, independent of its originator's control.

What was true of works on canvas was equally true of portraits on photographic stock. In the United States, it took a lawsuit that went all the way to the Supreme Court in 1884 merely to establish that copyright protection covered photographs at all. Interestingly enough, the case involved an action brought by Napoleon Sarony over the unauthorized reproduction of one of his many full-length portraits of Oscar Wilde, some 85,000 copies of which had been printed and sold by the Burrow-Giles Lithographic Company without the permission either of the photographer or of the subject.[27] Wilde, whose face was lifted, so to speak, by countless advertisers during his American lecture tour of 1882, understood sooner than most of his British contemporaries how difficult it would be to keep a sitter's image safe from appropriation or alteration. Once an image was committed to a visual medium, there was little that could prevent it from entering mass circulation in unauthorized forms or from being put into the service of agendas abhorrent to its originator.

No laws, for instance, could stop the comic artist from using serious portraiture as the basis for exaggeration and caricature. Many late Victorian portraits served as fodder for a group of artists who enjoyed their heyday at a time when so much attention was paid to the individual face: professional caricaturists. The urbanization of England in the late nineteenth century gave rise to a new sensibility, somewhat akin to what Americans think of now as (in the words of songwriter Billy Joel) a "New York state of mind"—cynical, sophisticated, and keenly appreciative of anything that seemed to puncture pretensions. Alongside the market for idealized representations of writers and artists as lofty beings representative of genius flourished an equally strong desire to see the physical appearances of the great and famous treated irreverently. On the one hand, newly educated and mobile segments of society, such as the lower-middle and the working classes, studied portraits as sources of instruction—almost as visual versions of conduct manuals—and emulated the dress and self-presentation they found there. On the other hand, they were happy to see their alleged betters brought low through caricature. (This was the same impulse that encouraged music-hall performers of the day to "take off" the "toffs" through comic song and impersonation.) But this taste for comic deflation could transcend class origins, for there was no finer practitioner of the art of caricature, whether in prose or in ink-and-wash drawing, than the hyper-gentlemanly Max Beerbohm, who began his career

while still an Oxford undergraduate. Beerbohm was happiest when skewering those nearest to him: men (but rarely ladies) of his own class, and especially other writers or artists, including those among his circle of intimates.

Caricature functioned as the necessary flip side of idealization. Throughout the last decades of the century, moreover, caricature and serious portraiture alike worked as agents of social regulation, especially in politically controversial matters of gender and sexuality. Part of the public animus that exploded during and after the Oscar Wilde trials of 1895 was the result of representations that had made Decadent writers look "monstrous" and "unnatural" to conservative viewers. Much of the war waged in the press against the New Woman, too, took the form of visual lampooning of the figure— especially the figure of the female writer—who embodied feminist rebellion. While portraits of authors and artists offered limitless commercial potential for those involved in the marketing of culture, these images also served as political instruments. They were immensely useful to anyone out to discredit new movements by laughing at or inspiring revulsion against the advocates of these movements. Yet they could be equally valuable to those who wished to provoke favorable responses by portraying aesthetes, socialists, New Women, and other advanced sorts of writers and artists as physically attractive and appealing.

With so much at stake in matters of representation involving the human face and body, it is no wonder that the late Victorian period also saw a boom in self-portraits. Drawing or painting oneself allowed the artist to exercise some degree of control over how that self would appear, at least initially, before the public. As Shearer West has said,

> In self-portraits artists did not simply present their status and gender identities in an unthinking or un-selfconscious way. . . . [rather,] artists realized that they could project particular ideas about themselves. This deliberate "self-fashioning" has rarely been absent. . . . Because artists were conscious about their own status and where this placed them in the social hierarchy, they could use the tool of self portraiture to enact roles that declared their aspirations. . . . Such self-presentation could be probing, revealing, theatrical, experimental, or arbitrary.[28]

West's use of words such as "probing" and "experimental" reminds us that the enormous interest in producing self-portraits also reflected a broader phenomenon, one that proved just as important in the textual sphere as in the visual arts. Fin-de-siècle literary movements such as realism and impressionism encouraged a heightened self-consciousness and the frank recording of personal experience in general, even as the scientific world developed new theories of the mind that stimulated greater psychological mapping of the self by non-scientists. Memoirs and autobiographical writings proliferated alongside these spectacles of "self-fashioning" through painting or drawing.

If these new approaches to psychology led women and men at the end of the nineteenth century to appraise faces (their own, as well as others') with keen interest, looking for the physiognomical keys to character, such theories also encouraged the late Victorians to compose their expressions deliberately in ways that would send a desirable message. In an age when the printed advertisement first reigned supreme, the individual face became a form of visual promotional literature, a personal billboard or poster, selling to spectators the idea of its bearer as a figure of importance. This was especially true in the case of writers and artists, who (like Tennyson) wished to be seen as persons of

genius and who thus tried to cultivate the appearance of genius. In late nineteenth-century portraits, we can find sitters conspiring with portraitists to produce a look of heightened spirituality, thought, and intensity, in order to impress upon the viewer the idea that there was a creative spark firing the face from within. Following Tennyson's lead, writers and artists worked hard to prove to the public that they had both a brain and a soul, through the kinds of representations of their faces that they authorized. It was no longer enough to write a book or paint a picture; one also had to look the part of the creative artist. The images that follow in this volume show us women and men relying upon various poses and even props—desks, pens, bookshelves, easels, palettes, brushes, etc.—to assist them in this necessary task of performance.

* * *

THE EXHIBITION from which the current volume emerged was titled *Beyond Oscar Wilde*. It is with Wilde himself that this introduction ro *Facing the Late Victorians* should end, for beyond and ahead of most of his contemporaries, Wilde recognized and explored the implications of living in a world dominated by faces. He also acknowledged both the welcome opportunities and the perils. Late Victorian writers and artists, male and female alike, might take advantage of the possibilities opened up by the ever-increasing circulation of images and, if they wished, might fill all of London, at the very least, with portraits of themselves. But they could neither control how those images would be received nor could they escape them. As time went on, anonymity was no longer an option.

I conclude, therefore, with an example of the wisdom contained in Wilde's painfully self-aware fairy tale from 1891, "The Birthday of the Infanta." This was a story set in Renaissance Spain, yet clearly offered as a commentary upon the cultural milieu of late Victorian London. In Wilde's narrative, a *naif*, a deformed and ugly dwarf, comes out of the forest and is carried off to the king's court to entertain the princess with his clumsy dancing. Having lived in solitude, with no knowledge of his own appearance or of how it is perceived by others, he mistakenly believes that the derisive laughter of the spectators is a joyous and appreciative response to his performance, and that the sight of him has inspired love. But he finds himself alone afterwards in a great hall, with a mirror at one end. There, he encounters what he assumes to be a monster:

> *It imitated him. He struck at it, and it returned blow for blow. He loathed it, and it made hideous faces at him. . . .*
>
> *When the truth dawned upon him, he gave a wild cry of despair, and fell sobbing to the ground. So it was he who was misshapen and hunchbacked, foul to look at and grotesque. He himself was the monster, and it was at him that all the children had been laughing, and the little Princess who he had thought loved him— she too had been merely mocking at his ugliness, and making merry over his twisted limbs. Why had they not left him in the forest, where there was no mirror to tell him how loathesome he was?* [29]

For better and for worse, fin-de-siècle British culture became the equivalent of a great hall of mirrors. Images of faces, including representations of writers' and artists' faces, were the new and inescapable accompaniments to daily life. They would make the physical appearance of the producer, moreover, inseparable from the circulation, interpretation, and reception of literary and visual texts.

The Age of Oscar Wilde has bequeathed as part of its legacy its artists' and writers' obsessions with visual reflections and with self-reflection, handing down those fixations first to the twentieth century and now to a new millennium. Today, to scrutinize portraits from the end of the nineteenth century is to *face* this shared fascination with establishing the meanings—especially those meanings linked to the politics of class, gender, and sexuality—of the human image. This volume invites us simultaneously to consider how Wilde's contemporaries read the portraits of one particular social category, the creative artist, and to engage in our own constructions of meaning for the images reproduced here. To do so is to feel, if only for a moment, our intellectual resemblance to the late Victorians and to experience the past and the present being drawn together.

Notes

1 Colin Ford, *Julia Margaret Cameron: 19th Century Photographer of Genius* (London: National Portrait Gallery, 2003), 46.

2 *The Letters of Alfred Tennyson, Vol. 3: 1871–1892*, ed. Cecil Y. Lang and Edgar F. Shannon, Jr. (Oxford: Clarendon Press, 1990), 208n.

3 Malcolm Warner, "Portraits of Men," in Peter Funnell, Malcolm Warner, et al., *Millais Portraits* (Princeton, NJ: Princeton University Press, 1999), 171.

4 Dennis Denisoff, *Sexual Visuality from Literature to Film, 1850–1950* (Houndmills, UK: Palgrave, 2004), 78.

5 Ella Hepworth Dixon, *My Flirtations*, by Margaret Wynman [pseud.] (London: Chatto & Windus, 1892), 2.

6 Ella Hepworth Dixon, *As I Knew Them: Sketches of People I Have Met on the Way* (London: Hutchinson, 1930), 34.

7 Merlin Holland, *The Wilde Album* (London: Fourth Estate, 1997), 50.

8 Elizabeth Wilson, *Adorned in Dreams: Fashion and Modernity* (Berkeley: University of California Press, 1985), 158.

9 Shelton Waldrep, *The Aesthetics of Self-Invention: Oscar Wilde to David Bowie* (Minneapolis: University of Minnesota Press, 2004), 70.

10 Simon Houfe, *The Dictionary of British Book Illustrators and Caricaturists, 1800–1914* (Woodbridge, UK: Antique Collectors' Club, 1978), 158–83.

11 Barbara Onslow, *Women of the Press in Nineteenth-Century Britain* (London: Macmillan, 2000), 13.

12 Claude A. Prance, "The Bookman," in *British Literary Magazines: The Victorian and Edwardian Age, 1837–1913* (Westport, CT: Greenwood, 1984), 44.

13 H. G. Wells, "In the Modern Vein: An Unsympathetic Love Story," in *The Complete Short Stories of H. G. Wells*, (1927; repr., London: Ernest Benn, 1974), 491.

14 Malcolm Rogers, *Camera Portraits: Photographs from the National Portrait Gallery, London, 1839–1989* (New York: Oxford University Press, 1990), 9.

15 Rosemary Ashton, *George Eliot: A Life* (New York: Penguin, 1998), 275.

16 George Gissing, *New Grub Street* (1891; repr. New York: Penguin, 1968), 78–79.

17 Thomas Hardy, *Jude the Obscure* (1896; repr. New York: Penguin, 1998), 78.

18 Oscar Wilde, *The Picture of Dorian Gray*, in *The Annotated Oscar Wilde: Poems, Fiction, Plays, Lectures, Essays, and Letters*, ed. H. Montgomery Hyde (New York: Clarkson Potter, 1982). 183.

19 Gertrude Atherton, *Adventures of a Novelist* (New York: Liveright, 1932), 184.

20 Ella D'Arcy, "Two Stories: I—The Death Mask," *Yellow Book* 10 (July 1896): 270.

21 D'Arcy, 270–71.

22 Walter Pater, "Leonardo da Vinci," in *Strangeness and Beauty: An Anthology of Aesthetic Criticism, 1840–1910*, vol. 2, *Pater to Symons*, ed. Eric Warner and Graham Hough (Cambridge: Cambridge University Press, 1983), 23–24.

23 Sarah Grand, "The Undefinable: A Fantasia," in *Daughters of Decadence: Women Writers of the Fin-de-Siècle*, ed. Elaine Showalter (London: Virago, 1993), 282.

24 Grand, 287.

25 Laura Marholm Hansson, *Modern Women: An English Rendering of Laura Marholm Hansson's 'Das Buch der Frauen' by Hermione Ramsden* (London: John Lane, 1896), 83–84.

26 Margaret Diane Stetz, "Life's 'Half-Profits': Writers and Their Readers in Fiction of the 1890s," in *Nineteenth-Century Lives: Essays Presented to Jerome H. Buckley*, ed. Laurence Lockridge, et al. (Cambridge: Cambridge University Press, 1989), 172–75.

27 Mitch Tuchman, "Indelible Images: Supremely Wilde," *Smithsonian*, May 2004, 18.

28 Shearer West, *Portraiture* (Oxford: Oxford University Press, 2004), 173.

29 Oscar Wilde, "The Birthday of the Infanta," in *Oscar Wilde: Complete Short Fiction*, ed. Isobel Murray (Oxford: Oxford University Press, 1979), 200–201.

FACING THE LATE VICTORIANS

Portraits of Writers and Artists from the Mark Samuels Lasner Collection

William Allingham (1824–1889)

POET AND JOURNALIST

watercolor, [ca. 1880]
by Helen Allingham (1848-1926)

Marriages between late Victorian writers may not have been common, but those between writers and visual artists were extremely rare, especially when it was the woman who was the painter. Helen Allingham's watercolor of her husband, the poet William Allingham, serves as a document of one of these unusual unions. There were relatively few professional opportunities open to female portraitists, but many more for women who chose to make their livings as illustrators or as painters of landscapes and domestic genre scenes. Helen Allingham's own career followed this path, and her version of William reflects a domestic style of portraiture, in contrast to the formal, dark, and oversized oils of the male Royal Academicians who were hired to produce the official likenesses of writers for public consumption. Indeed, in this small and loving image, she has given her husband the mild, guileless look of one of the open-faced children or tame rabbits that decorated her paintings of cottage gardens.

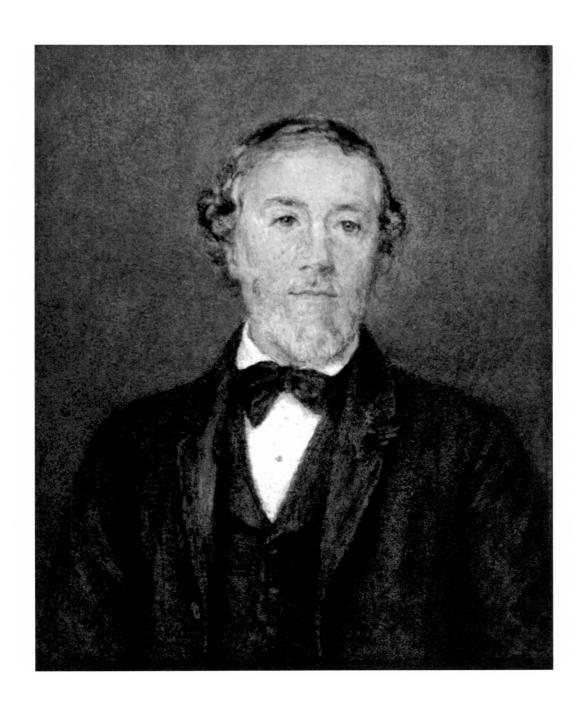

William Archer (1856-1924)

Mr. William Archer
pencil, ink, pastel, and watercolor, [1896]
by Sir Max Beerbohm (1872-1956)

For Max Beerbohm, who as a young man was afflicted with a tendency toward hero-worship and who fought it consciously by demolishing his gods through satire, there was nothing funnier than the sight of idolatry in others. In 1904, he would produce a stinging double-caricature, titled *Henrik Ibsen, Receiving Mr. William Archer in Audience*, in which the Norwegian playwright glumly extends his foot to be kissed by the British translator of his plays, who is kneeling on the ground before him and cradling the booted object as though it were a bit of the True Cross. Beerbohm's portrait of 1896 was much kinder to William Archer, who merely stands rapt, looking rather like a bust on a slim pedestal himself, before the grotesquely ugly head of Ibsen that sits atop a marble column, indifferent to his wide-eyed gaze.

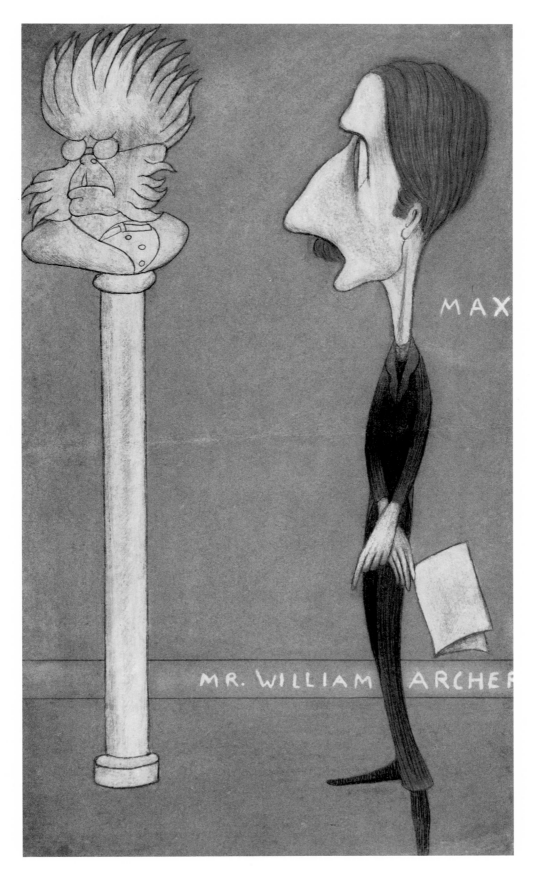

MAX

MR. WILLIAM ARCHER

27

Matthew Arnold (1822-1888)

CRITIC AND POET

and his wife, *Frances Arnold* (née Wightman) (1825-1901)

> photographs, albumen cartes des visites, [1880s]
> by Elliott and Fry, London
> tipped in Matthew Arnold, *Poems* (London, 1895)

As photographs grew more common and more affordable, they played increasingly diverse and important roles in late Victorian Britain. Even as they became staples of the commercial sphere—dominating newspapers and magazines, decorating posters in the streets and playbills at the theatre, and revolutionizing the look of modern advertising—so they also served to grease the wheels of middle-class social life. The sending of photographs, especially portraits, to friends and family became a new domestic ritual. (Often this meant that it was women who were in charge of securing and presenting the images, for wives, sisters, and daughters were expected to see to the niceties of social relations in general.) Exchanges of photographs, moreover, could also be combined with existing social gestures specific to the world of writers. For an author to enclose a photograph with a presentation copy of a book, for instance, or for a recipient to tip in a photograph received from the author suggested an extra level of intimacy or a way of marking a special occasion. The volume of Matthew Arnold's *Poems* presented posthumously by his widow, Frances Arnold, as a wedding present to Lilian Darlington has photographs of both the Arnolds pasted into it.

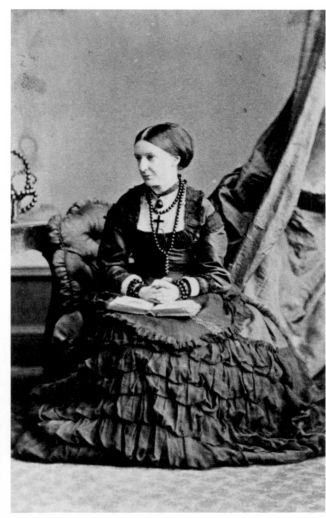

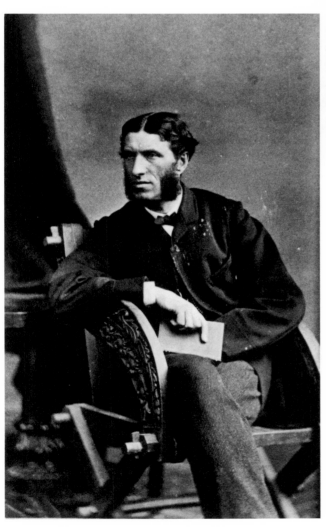

Sir J. M. [James Matthew] Barrie (1860-1937)
NOVELIST AND PLAYWRIGHT

and Mary de Navarro (née Mary Anderson) (1859-1940)
ACTRESS AND MEMOIRIST

caricature, *Result of the Match, 1898,* by Sir Bernard Partridge (1861-1945), reproduced in *The Allahakbarrie Book of Broadway Cricket* (London, 1899)

Satire in general was considered a mode ill-suited to women practitioners, though this was doubly true in the visual arts. Although some women writers did manage to conquer this bias and to publish satirical pieces, and some women artists did publish an occasional cartoon, no male-dominated, mainstream British periodical such as *Vanity Fair* or *Punch* would have felt comfortable with a female caricaturist on staff. Women might serve, moreover, as the targets of malicious, unsparing caricature, so long as the object of ridicule could be justified as being a "type"— the New Woman, the Girton Girl, or the bluestocking, for example. But individual women usually were off-limits. When male artists did draw comic portraits of identifiable women, they were careful to be as gentle (and thus as gentlemanly) as possible. In this double caricature, the illustrator Bernard Partridge, who had worked with New Women authors such as Ella Hepworth Dixon, has applied a late Victorian double standard of ridicule to one of the annual matches staged by J. M. Barrie's private cricket club, called the "Allahakbarries." Partridge depicts Barrie as a sad-eyed, big-headed, shrunken figure, defensively hugging his phallic bat, while he turns the American actress, Mary Anderson (who had left the stage, married Antonio de Navarro, and moved to Broadway, in Worcestershire), into a dignified, attractive amazon.

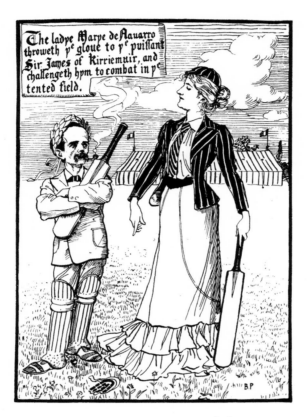

The ladye Marye de Nauarro throweth y^e gloue to y^e puiſſant Sir James of Kirriemuir, and challengeth hym to combat in y^e tented field.

RESULT OF THE TEST MATCH, 1898.

Aubrey Beardsley (1872-1898)

ARTIST AND ILLUSTRATOR

lithograph (proof inscribed by artist to subject), 1897
by Sir William Rothenstein (1872-1945)

As an artist given to satirical drawings, Aubrey Beardsley was well aware of the potential for carica-
ture in his own physical features. Tall and fine-boned, with a slenderness attributable in part to tuber-
culosis, he chose to exaggerate the eccentricity of his appearance with bohemian styles of dress and
haircuts that emphasized the sharp angularity of his face. His published self-portraits made fun
simultaneously of the insignificance of his own body, conventional stereotypes of manliness, his
public reputation as a "monstrous" decadent, bourgeois notions of propriety, and contemporary
journalism's obsession with images of celebrities as supposed revelations of the truth about their per-
sonalities. In the most famous of these comic drawings, *Portrait of Himself* for the October 1894 issue
of the *Yellow Book*, Beardsley depicted his tiny, mobcap-covered head peeking out slyly from bed-
clothes that looked like a gigantic woman's parted skirt. But in the hands of his friend, the artist
William Rothenstein, Beardsley became quite a different sort of subject—brooding, vulnerable, and
melancholy, as indeed he often was toward the premature end of his short life.

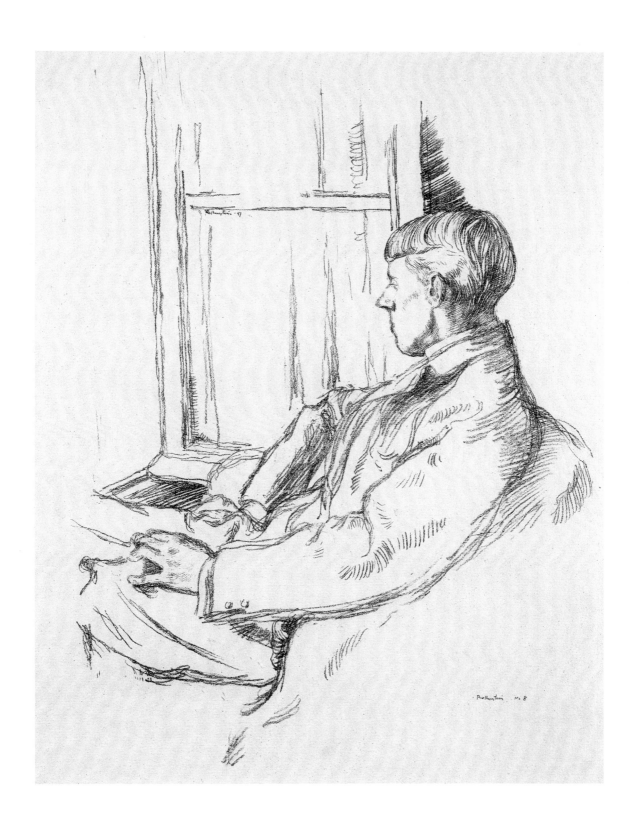

33

Aubrey Beardsley (1872–1898)

photograph, silver gelatin, [1897]
by Abel, Menton

The circulation of photographs of artists in their studios and of writers in their studies became an important facet of the New Journalism of the late Victorian period. Viewers were meant to pore over these images and to learn about the habits of "genius" from them. But such photographs could also serve more intimate, private purposes. In 1897 Aubrey Beardsley, with his early death from tuberculosis only months away, traveled to the town of Menton on the French Mediterranean for his health. His room in the Hôtel Cosmopolitain became his little world, which his mother brightened by decorating it with objects dear to him, including photographs of his beloved sister (the actress Mabel Beardsley), his patron André Raffalovich, and his idol, the composer Richard Wagner. Too ill to pay visits in London or even in Paris, Beardsley had himself photographed in the setting where he now lived, worked, and worshiped—the prominence of the crucifix on his desk indicates his conversion to Roman Catholicism earlier in the year—and sent copies of this portrait to friends such as Herbert Pollitt, as a way of remaining connected to them.

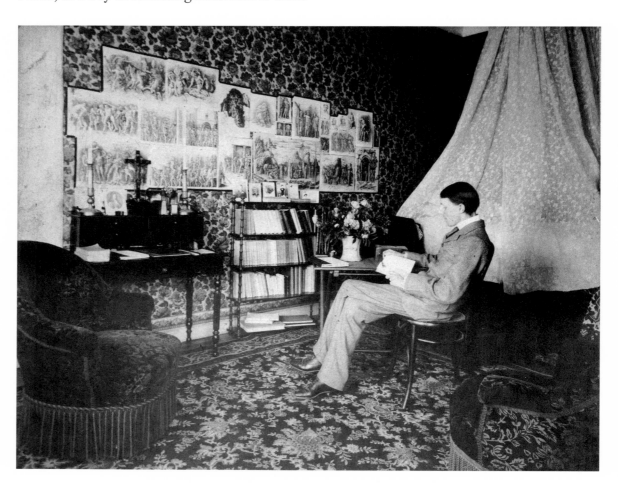

Sir Max Beerbohm (1872–1956)
WRITER AND CARICATURIST

with

Sir William Rothenstein (1872–1945)
PAINTER AND LITHOGRAPHER

> photograph, albumen cabinet card, [1893]
> by Gillman and Company, Oxford

To have oneself photographed with another man in a formal studio portrait was an accepted part of the experience of late Victorian homosocial relations among the well-to-do. It did not necessarily indicate an erotic connection—there was no such sexual relationship in the case of Beerbohm and Rothenstein—but it did serve to celebrate the intellectual and emotional intimacies that men were encouraged to form, especially in their youth. In fact, William Rothenstein was not Max Beerbohm's closest friend; that was Reginald Turner, his classmate at Oxford, who, like Beerbohm himself, first became part of Oscar Wilde's circle and then one of the writers affiliated with the *Yellow Book*.

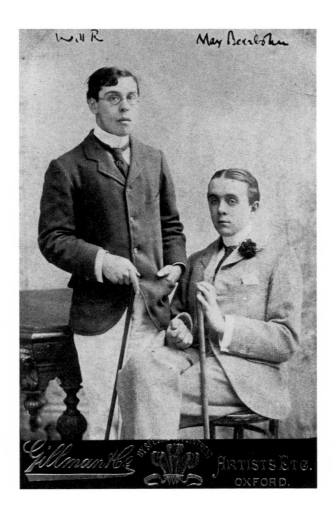

Sir Max Beerbohm (1872-1956)

Self-Caricature
pencil, ink, and watercolor, [ca. 1900]

Throughout his long life, Beerbohm would turn his caricaturist's pen against himself almost as often as he did against writers, artists, and other prominent men of the day. (A somewhat retrograde notion of chivalry restrained him from using female subjects, though there were rare exceptions, such as his malicious visions of Queen Victoria as a mound of black clothing with a fat face atop.) Just as the persona he constructed for his essays was modest, self-effacing, and sometimes rather foolish, so the figure that he drew in his comic self-portraits was someone always verging on the ridiculous, yet clearly unaware of his own absurdity. In this work, Beerbohm displays himself as a hyper-dandified gentleman, whose dignity wanes appreciably as the spectator's eye travels down the sheet of paper. He is at once androgynous, with an exaggerated hourglass shape, and not quite human, balanced on specks of feet that give him the look of a clothespin. In the ultimate self-deflating gesture, moreover, Beerbohm has positioned behind this carefully overdressed, arrogant *boulevardier* a shapeless, blotchy, undistinguished shadow, making the image a sort of double self-caricature, in which he skewers himself first for his affectations and then for his failure to live up to them.

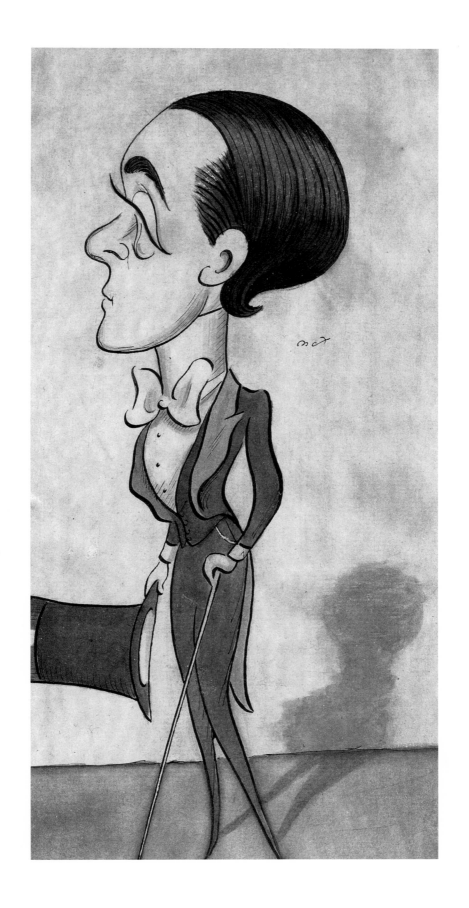

Sir Max Beerbohm (1872-1956)

pencil and ink, [ca. 1898-1899]
by Sir William Rothenstein (1872-1945)

"There was a likeness between them. As they gazed at each other each felt: Here am I—and then each felt: But how different. . . . Broken asunder, yet made in the same mould, could it be that each completed what was dormant in the other?" Those were the words that Virginia Woolf used, in her comic biography *Flush* (1933), when imagining the first meeting between the Victorian poet Elizabeth Barrett Browning and the latter's cocker spaniel. But the sentiments could have applied just as well to Max Beerbohm and Will Rothenstein, who encountered each other in 1893 when Rothenstein arrived at Oxford with a commission from the publisher John Lane to sketch portraits of university notables. Both Beerbohm and Rothenstein were very young men who, nonetheless, seemed sophisticated and self-possessed beyond their years. Yet each had advantages that the other admired and lacked. Beerbohm—then an Oxford undergraduate and amateur caricaturist— regarded with awe Rothenstein's brilliance as a painter, his formal training in the visual arts, the cosmopolitan polish he had acquired as an art student in Paris, his unflagging energy, and, above all, his certainty of purpose. Rothenstein, in turn, viewed the multi-talented Beerbohm with appreciation and perhaps a touch of envy. This portrait from the late 1890s suggests some of the reasons why. In it, Rothenstein has captured the quality of nonchalance and indifference to the gaze of others that only a university-educated gentleman could command in the hierarchical world of late Victorian England (as well as the absence of struggle possible for someone not born a Jew, like Rothenstein). So, too, the drawing celebrates Beerbohm's physical grace. As Beerbohm would make wickedly clear in caricatures such as *Will R. Laying Down the Law*, Rothenstein's own face and figure certainly could not be his tickets to success.

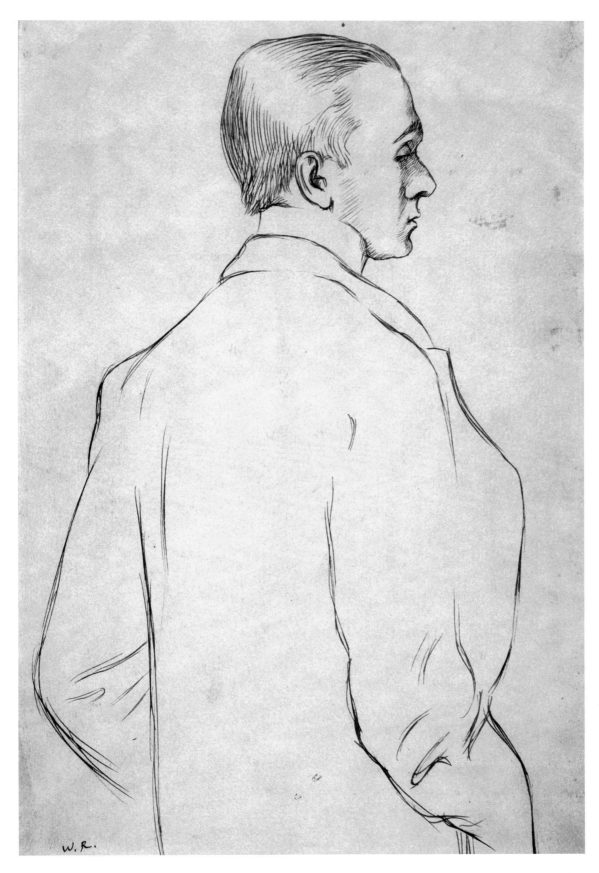

W. R.

Wilfrid Scawen Blunt (1840-1922)

POET, TRAVEL WRITER, AND DIARIST

photograph, albumen, [ca. 1882]
tipped in Wilfrid Scawen Blunt, *Esther, Love Lyrics, and Natalia's Resurrection*
(London, 1892)

Unfortunately, this image of Wilfrid Scawen Blunt does not show him as he most liked to be represented, in full Arab costume. Before T. E. Lawrence came along, Blunt could lay claim to being Britain's most famous Orientalist, hopelessly smitten with the romance of desert life, as well as with the glamour of Arabian horses, and given to dressing up accordingly. He was also a political radical, whose sympathy with Irish independence movements brought him into contact with Augusta Persse Gregory. This volume of Blunt's poetry, presented by him to Lady Gregory, illustrates another function of the photograph in the late Victorian period: such objects could serve as trophies of sexual conquest, for Lady Gregory has pasted in the portrait of her lover as a memento of their affair.

Sir Edward Burne-Jones (1833-1898)

PAINTER

Burne-Jones Painting
pencil, [ca. 1884-1895]
by George Howard, Ninth Earl of Carlisle (1843-1911)

Although the public might have assumed that an artist who created such large, solemn oils of soulful Pre-Raphaelite maidens would have been a man of gloomy temperament, Burne-Jones was in fact playful and irreverent. He loved nothing better than to poke fun at himself, especially through the long series of self-caricatures that he shared with relatives and friends. These quite charming sketches usually depicted a shabby, stooping figure with owlish eyes, scruffy facial hair, and an expression of permanent surprise. Very different in spirit, however, was the portrait of him done by George

Howard, an aristocrat whose enthusiasm for art drove him to become both a patron of the later Pre-Raphaelites and an accomplished amateur painter. Howard's version of Burne-Jones emphasized the artist's identity as a serious, no-nonsense professional, engrossed in his work and seemingly oblivious even to the presence of someone drawing him a few feet away.

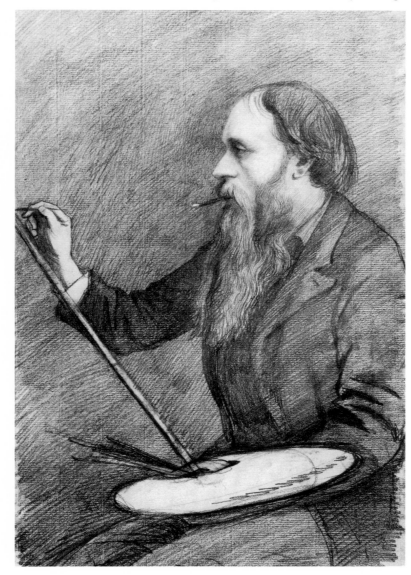

Sir [Thomas Henry] Hall Caine (1854-1931)

NOVELIST

Mr. Hall Caine
ink on blue paper, [1898]
by Sir Max Beerbohm (1872-1956)

Self-promotion may have become a necessity in the age of the New Journalism and of modern advertising, but a talent for making much of oneself did not always endear one to other artists and authors. It could prove particularly distasteful to those, such as Max Beerbohm, who were torn between competing ideals of conduct—attracted, on the one hand, by the brilliant public performance of a self that Oscar Wilde achieved, yet also attached to earlier notions of gentlemanly modesty and reticence. Had Hall Caine been a genius on the level of Wilde, then perhaps Beerbohm would not have found his self-publicizing so contemptible. But Caine was, in Beerbohm's eyes, merely a popular success, not a great writer. Hence, in this caricature, Beerbohm gleefully reduced him to an undignified figure wearing a sandwich board lettered with his own name.

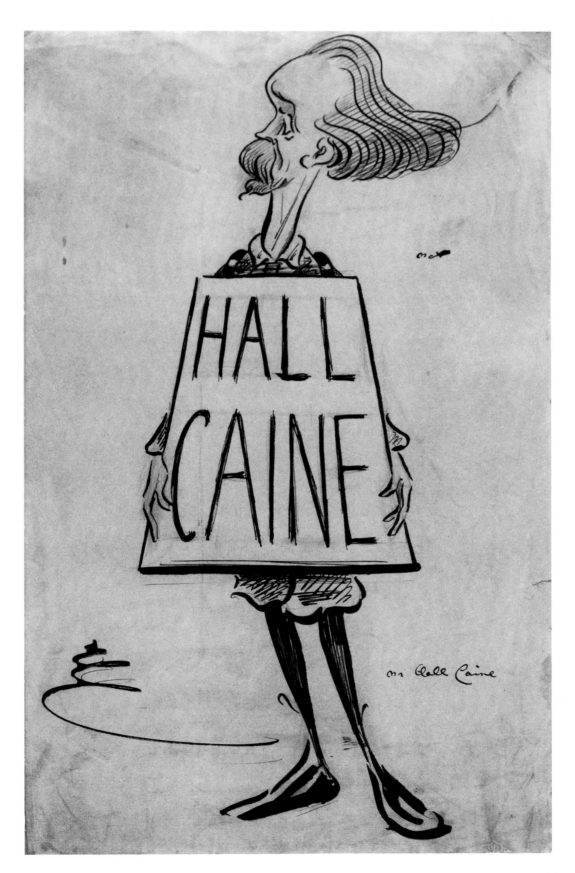

Mr Hall Caine

Ella D'Arcy (1856?-1937)

NOVELIST, SHORT STORY WRITER, AND ASSISTANT EDITOR OF THE *Yellow Book*

painting, *A Lady* [ca. 1892–1894], by Philip Wilson Steer (1860–1942), repro-
duced in the *Yellow Book* 2 (July 1894)

As an ambitious publisher of the 1890s, John Lane was keenly alive to the publicity value of putting images of new writers before the public. He could be an Irresistible Force, wheedling even reticent authors into surrendering themselves to photographers or painters. But he met his Immovable Object in Ella D'Arcy, the *Yellow Book* contributor and then assistant editor of the magazine, who worked under Henry Harland. Unlike George Egerton, Richard Le Gallienne, and others, she refused to become one of what Lane called his Bodley Heads, playing upon the name of his publishing firm (and also playing off the notion of trophy-hunting). Nevertheless, the July 1894 issue of the *Yellow Book* did contain a reproduction of a painting by Philip Wilson Steer (1860–1942), a teacher at the Slade School of Art, that is allegedly a portrait of D'Arcy, though identifed only with the title *A Lady*. Did either the artist or Lane himself manage to persuade her to sit for it, only to have her balk in the end at being known as the subject? D'Arcy was famously elusive as well as secretive, and the story behind this image remains a matter of speculation.

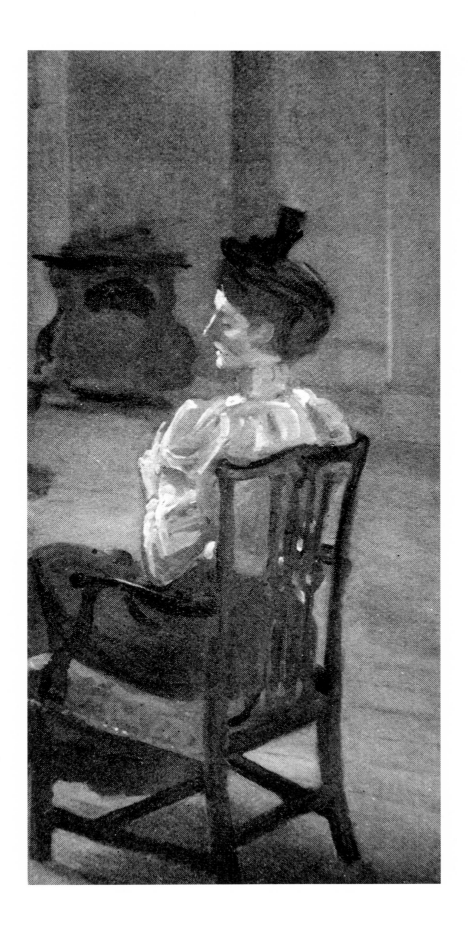

George Du Maurier (1834-1896)

CARTOONIST, ILLUSTRATOR, AND NOVELIST *(Trilby)*

photograph, carbon, [ca. 1890s]
by Elliott and Fry, London

Wrongly counted among the enemies of the aesthetic movement because he chose to treat it wryly in so many of his cartoons for *Punch*, Du Maurier was far more at home in the company of the aesthetes than of the art-hating philistines. Indeed, he was not only an idealist and a worshiper of Beauty (especially of women's beauty), but a bit of a dandy, not so different in appearance from the figures of the 1880s, such as J. M. Whistler, whom he caricatured in his drawings. This cabinet card—a format related to, but larger in size than, the photographic carte-de-visite—shows Du Maurier as a dapper gentleman-artist affecting a slightly French manner. Certainly, his own sentimental devotion to the world of Paris's Latin Quarter, which was fully in evidence in his bestselling novel *Trilby*, outstripped that of many of the Francophilic artists whom he made the subjects of his visual lampoons.

George Egerton [Mary Chavelita Dunne Bright] (1859-1945)
SHORT STORY WRITER AND NOVELIST

photograph, albumen cabinet card, [ca. 1894]
by J. Russell and Sons, London

Images of late Victorian writers circulated for many reasons. Among the most important were to publicize their works and, in the case of New Women authors such as George Egerton, to reassure conservative audiences that even writers who produced challenging feminist texts were conventionally attractive and feminine in appearance. John Lane of the Bodley Head, George Egerton's publisher, encouraged his prize property to have herself photographed and to let journalists reproduce the results. He also engaged the artist E. A. Walton to paint her and then used the portrait in Vol. V (April 1895) of the *Yellow Book*. To her dismay, however, George Egerton found that cartoonists for *Punch* and other magazines seized upon her physical features—especially her short hair and pince-nez glasses—and, breaking with the tradition of gentlemanly restraint, produced wildly unflattering caricatures of the New Woman as a mannish-looking harpy that clearly were based on photographs of her such as this one.

George Eliot [Mary Ann Evans] (1819-1880)
NOVELIST

pencil, [ca. 1878]
by George Du Maurier (1834-1896)

The career of George Eliot had a special meaning for the Victorians, for she was one of the first examples of what we might now call a successful crossover. No female novelist in England before her had ever been taken so seriously by the men who were her contemporaries or respected by British male intellectuals as a thinker on their own level. Numerous artists were eager to paint or draw the portrait of this anomalous creature, who represented the female sage. Gradually, as images of her circulated, her distinctive countenance became the standard for how an intelligent woman was supposed to look: solemn, dignified, heavy-featured, and also unmistakably homely and unappealing. That was certainly the way she was viewed by George Du Maurier, the writer and cartoonist who was an occasional guest at the house that Eliot shared with her partner in life, George Henry Lewes. Unwritten codes of middle-class social propriety forbade male artists from caricaturing individual women too viciously, so Eliot escaped

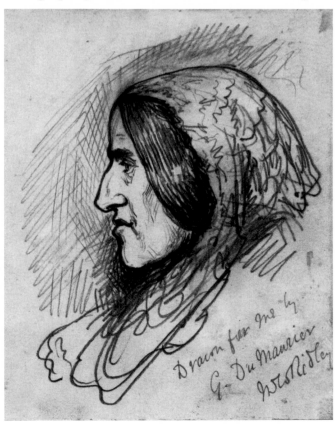

the pain of seeing her unconventional appearance lampooned directly. But there were obvious echoes of Eliot's features in the generic bluestockings as hatchet-faced grotesques that Du Maurier drew for *Punch*. Even this non-satirical portrait of Eliot, sketched from memory, shows how physically repulsive he seemed to find her.

Michael Field [Katherine Bradley (1848-1914) and Edith Cooper (1862-1913)]
POETS

> photograph, silver gelatin carte-de-visite (likely a copy of a platinotype),
> [1884-1889]
> by Bromhead, Clifton

The carte-de-visite was quite literally a calling card—a cheaply produced form of portrait image mounted on a sturdy cardboard backing that often measured about four inches by two-and-one-half inches, just the right size to be left on a tray when paying one's social visits. This format made portrait photographs not only easy to distribute and circulate by hand, but to send by post, as well as to collect and preserve in albums. It is telling that the aunt-and-niece lesbian couple called Michael Field would have wanted their own carte-de-visite to be a double headshot, with the closely positioned faces almost suggesting the conjoined relationship of their brains, for they issued their poetry and verse dramas as collaborative works. Living together in the 1880s, moreover, first in Bristol and then in Reigate, they also socialized as a couple, moving in the circles of "advanced" artists and aesthetic writers who could appreciate their absorption in the Greek classics in general and the Sapphic tradition in particular.

Harry Furniss (1854-1925)

CARTOONIST

Self-caricature in autograph letter to "My Dear Wallis,"
25 September 1901
ink

With the simultaneous rise of two late Victorian cultural crazes—for portraits of celebrities and for the mockery of prominent persons—it was possible for British artists to win fame and to make quite handsome livings through caricature. Harry Furniss began his career in his native Ireland, cartooning for the Irish version of *Punch*. Like many of his ambitious compatriots (including G. B. Shaw, Oscar Wilde, and W. B. Yeats), he soon realized, however, that there were greater opportunities for

him in England. In London, he became one of the premier caricaturists of the day, known particularly for his irreverent views of politicians. But this sketch shows him turning his art to more private uses, as well as back upon himself. Furniss depicts himself as a hapless figure, overwhelmed by the demands of finishing the text of what is probably his 1901 memoir, *Confessions of a Caricaturist.*

Sarah Grand [Frances Clarke McFall] (1854-1943)
NOVELIST

and

Sir W. S. [William Schwenck] Gilbert (1836-1911)
PLAYWRIGHT AND LYRICIST

photographs by Stereoscopic Co., London, reproduced in [W. T. Stead?],
*Notables of Britain: An Album of Portraits and Autographs of the Most Eminent
Subjects of Her Majesty in the 60th Year of Her Reign* (London: 1897)

Volumes that assembled photographs of the famous sometimes made for what we might call strange bookfellows. The figures so incongruously sharing one of the page openings were Sarah Grand (i.e., Frances Clarke McFall), the notorious New Woman novelist who supported radical causes from marriage reform to animal rights, and W. S. Gilbert, the socially conservative librettist for *Princess Ida* (1884), which used Tennyson's "The Princess" to make fun of higher education for women, and for *Patience* (1881), which satirized the male aesthetes and their female followers. *Notables of Britain* was only one of many published collections that encouraged bookbuyers to feel they were receiving inside glimpses of genius, however arbitrarily defined and juxtaposed. Similar titles available to consumers in the 1890s included *Portraits and Autographs: An Album for the People* (1890) which, for the price of one shilling and sixpence, allowed the purchaser to take home not only reproductions of photographs of everyone from "Her Majesty the Queen" to "Mr. William Morris," but reproductions of their signatures and even of snippets of their letters. Such volumes fueled the mania for studying faces, while also feeding the new passion for collecting autographs, as well as for analyzing handwriting (the latter hobby having supplanted phrenology as a way of accessing the hidden truths of personality).

A journalist—even a woman journalist—could make quite a decent living from turning out these books. This was doubly true, if short articles about or interviews with the subjects accompanied the images, and if the texts originally had been commissioned by magazines or newspapers. Helen C. Black, for instance, made a specialty of double-dipping, producing photographically illustrated volumes such as *Notable Women Authors of the Day: Biographical Sketches* (1893) for the Glaswegian firm of David Bryce and Son, and *Pen, Pencil, Baton and Mask: Biographical Sketches* (1896) for London's Spottiswoode & Co., by reprinting pieces written for the *Lady's Pictorial*, the *World*, *Lloyd's Weekly*, *Black and White*, and other venues.

The market for portraits of prominent figures was immense, especially for those (such as this "at-home-in-her-study" view of Sarah Grand) that seemed to take the spectator into a private realm. But the images themselves were as deliberately constructed as anything manufactured for *People* magazine by a Hollywood publicist today, as we can see from this photograph of a New Woman posed (although she was not a Catholic) near an immense string of rosary beads.

52

MADAM
SARAH GRAND.

MR.
W. S. GILBERT.

"My meaning simply is, that whatever I have
tried to do in life, I have tried with all
my heart to do well; that whatever I have
devoted myself to, I have devoted myself to
completely; that in great aims as in small,
I have always been thoroughly in earnest."

(Charles Dickens in "David Copperfield")

John Gray (1866-1934)
POET

lithograph, [1896]
by Charles Haslewood Shannon (1863-1937)

Gifted though John Gray may have been as a poet, it seems unlikely that his literary star would have risen so swiftly had he not been endowed with the asset of a beautiful face. In an age when the worship of lovely countenances was newly supported by the industries of publicity, journalism, and photography, rich and powerful men associated with the aesthetic movement vied for Gray's favor the way royalty and business magnates fought over Lillie Langtry. He was indeed the center of a homoerotic circle of worship, with Oscar Wilde as Admirer-in-Chief. It was, however, a measure of Wilde's brilliance as an artist that he could also step back from the two phenomena in which he was so deeply implicated—i.e., the cult of male beauty and the promotion of careers through the creation or circulation of portraits—to interrogate both of these critically in his 1890 novel, *The Picture of Dorian Gray,* which was thought by many of Wilde's friends to have been inspired by John Gray. Charles Shannon's image of Gray, on the contrary, is a wholly uncritical tribute to the charm of the poet's dreamy, sensitive-looking profile.

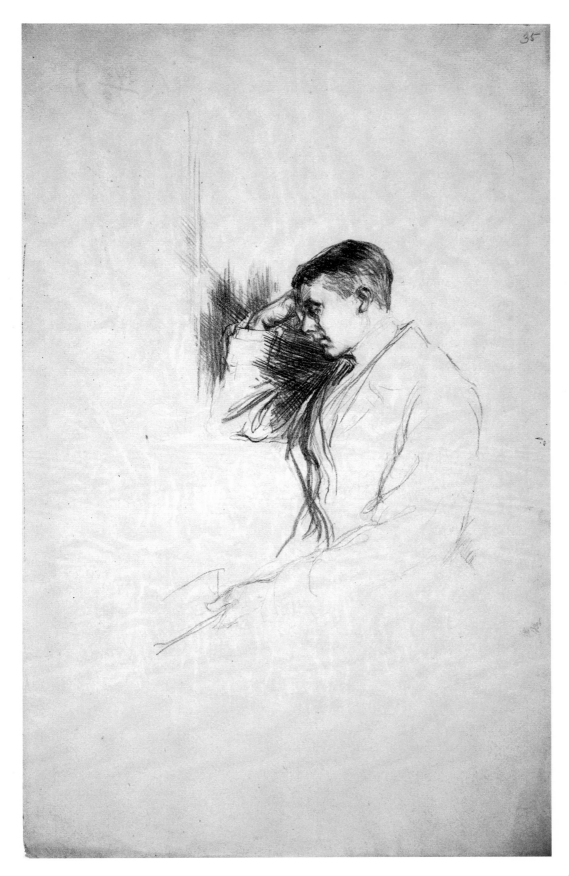

Thomas Hardy (1840-1928)

NOVELIST AND POET

lithographic crayon (recto), sanguine and black crayon (verso), 1897
by Sir William Rothenstein (1872-1945)

Not only did Thomas Hardy feel doubtful about the world of the New Journalism and its merchandising of writers as celebrities to be swooned over by fans, but he turned that skepticism into literary capital. In his 1894 short story "An Imaginative Woman," he detailed the family tragedy that results when a female reader and less-talented poet becomes obsessed with a "true" poet (a man conveniently named Trewe). Her adulterous attachment to a figure she has never met reaches destructive heights when she gains access to a photograph of the writer and is sure that she sees in it the face of someone who needs her. Of course, Hardy's lack of enthusiasm for the circulation of authors' portraits may have had something to do with the fact that his own visage was less than matinee-idol handsome. To market images of him—even relatively flattering ones, such as this one by William Rothenstein—could win him no new following, although the publishers Sampson Low, Marston & Co. did gamely try by offering a "Photogravure Portrait of the Author" in each volume of the Wessex Novels edition of his works.

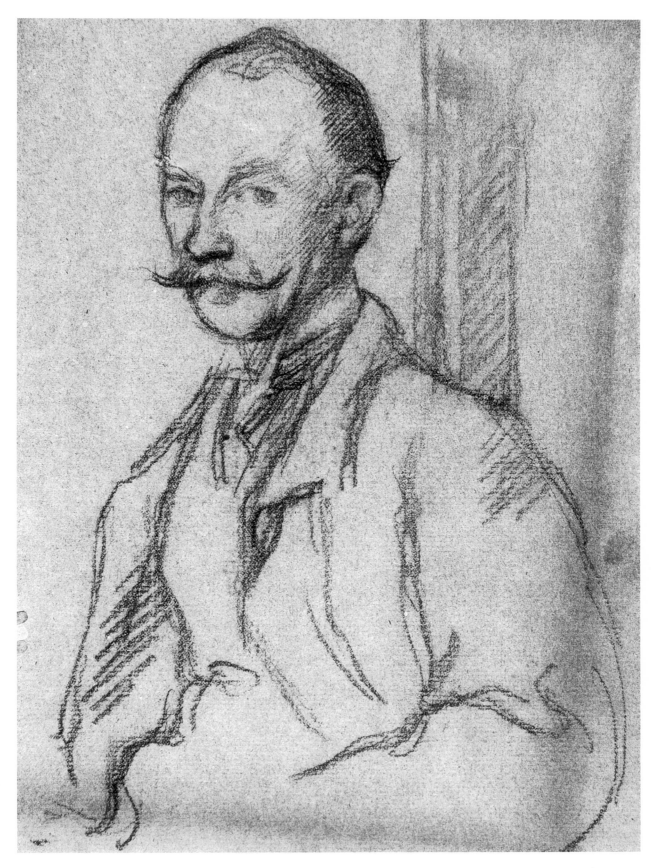

57

Henry Harland (1861-1905)

NOVELIST, SHORT STORY WRITER, AND LITERARY EDITOR OF THE *Yellow Book*

portrait sketch on autograph manuscript poem by Harland
ink, [1882]
by Sarah J. Eddy (1851–1945)

Like his fellow expatriate, J. M. Whistler, Henry Harland chose to invent a new life story (several different ones, in fact) on the boat over from America, giving himself origins that were far more distinguished and exotic than a middle-class childhood in New York. And like Whistler, too, Harland fashioned an appearance that would match his fictitious biography. His version of the continental dandy was perhaps a touch more restrained—closer to the goateed model of George Du Maurier and *sans* the Whistlerian monocle—but meant to suggest nevertheless that there was not a single drop of the unsophisticated Yankee in him. Although he never published plays, his instincts were theatrical, especially when it came to impersonation. While still living in New York in the 1880s, he began his career by immersing himself in Jewish American life and writing novels about Jews under a penname. In London, he affected a Russian-French identity and produced stories about the bohemians of Paris's Latin Quarter. But he came into his own as an editor, responsible for the literary contents of the Bodley Head's groundbreaking magazine of the 1890s, the *Yellow Book* (1894–1897). His achievements were, however, as much a result of collaboration as they were solo efforts, for his wife, the writer Aline Harland, was often working with him behind the scenes—a situation he acknowledged proudly in his novel about marriage as a creative partnership, *Grandison Mather*.

It started rose bud bore a rose,
It sad, discolored, misshapen flower.
I plucked it in an idle hour,
To make you it wear—
When lo! that mockery of bloom
Was rich with most daintiest perfume!
Henry Harland

Henry Harland

59

Frank Harris (1856-1931)

EDITOR AND SHORT STORY WRITER

"Had Shakespeare asked me . . ."
pencil, ink, and watercolor, [1896]
by Sir Max Beerbohm (1872-1956)

To the late Victorian literary world, still dominated by ideals of conduct forged at Oxbridge, Frank Harris was a fascinating curiosity—an American ball-of-fire who might be ridiculed as an ungentlemanly blowhard, but who nevertheless could not be ignored or dismissed. The self-promoting energy that he embodied was, as many of his English contemporaries recognized with a shudder, the wave of the future and, especially, the spirit of the New Journalism that was revolutionizing London's publishing industry. In 1892, George and Weedon Grossmith had devoted a chapter to lampooning him as "Mr. Hardfur Huttle, a very clever writer for the American papers," in their delightful comic novel, *The Diary of a Nobody*. Weedon Grossmith's accompanying caricature of him had emphasized Harris's almost preternaturally large, luxuriant moustache, which seemed to be strategizing for control of the rest of his face and winning. That same aggressive growth features prominently in Max Beerbohm's version of Harris, too—an image of him as the epitome of "cheekiness" in more ways than one (hence the bare bottom). The occasion for this privately-circulated caricature was an equally private discussion of the awful fate of Oscar Wilde, who was tried and imprisoned in 1895 for acts of "gross indecency" with men. Harris had couched his feelings of outrage over this injustice in terms meant to sound sympathetic. He asserted that he knew nothing of or about homosexuality personally, but that genius such as Wilde's always gave its possessor a kind of *droit du seigneur*—or, as Harris put it, "Had Shakespeare asked me, I would have had to submit." Beerbohm's imaginings of this absurd scenario make clear the unlikelihood of Harris ever "submitting" to anyone or anything, for there is no doubt which of these two figures—the leonine Harris and the mouse-like Shakespeare— will master which.

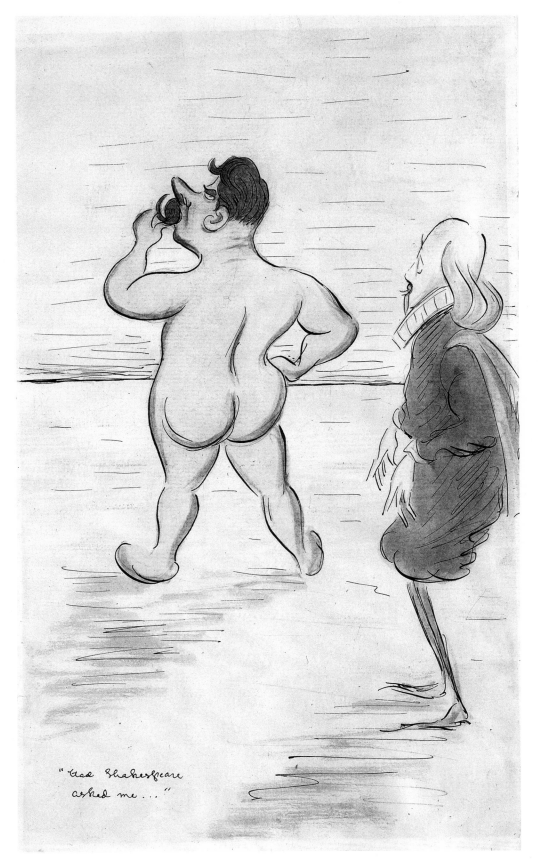

"and Shakespeare
asked me..."

W. E. [William Ernest] Henley (1849-1903)

POET, JOURNALIST, AND EDITOR

photograph, silver gelatin, [1899]
by Walter Biggar Blaikie (1847-1928)

If a career could be made in the late Victorian period out of talking up aestheticism and the philosophy of art for art's sake, it was nearly as easy to gain fame by talking them down. Just as the existence of the New Woman called forth a host of professional anti-feminists, so the flourishing of Oscar Wilde's reputation and the transatlantic distribution of representations of his "unmanly" dress and appearance gave rise to a counter-movement which advanced the prospects of writers who carried the banner of muscular masculinity instead. Chief among these was W. E. Henley, editor first of the *Scots Observer* (which became the *National Observer*) and then, in the late 1890s, of the *New Review*. This photograph of Henley is in the genre of the "author's study" shots so commonly reproduced in periodicals and volumes at the end of the century—portraits that treated writers almost as zoological curiosities, captured in their lairs. What this image renders invisible, however, is that the broad-shouldered, barrel-chested Henley, who was thought to stand for the macho ideal of action could, in fact, hardly stand at all. He suffered from a virulent form of arthritis, lost a foot to it, and lived always with pain.

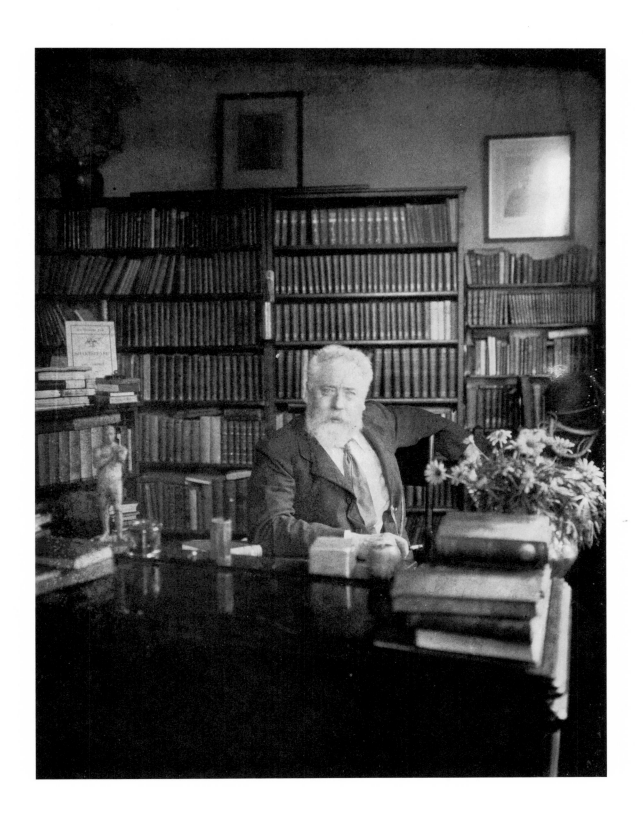

A. E. [Alfred Edward] Housman (1859-1936)

POET AND SCHOLAR

photograph, platinotype, [ca. 1894]
by Van der Weyde Light Studio, London

Photography was a perpetually changing (one might almost say perpetually *developing*) art through-
out the last years of the century. With each technological innovation came new possibilities for use
in portraiture. In the early 1870s, William Willis invented a technique for reproducing images on
paper by using a platinum compound. These permanent platinum prints, also called platinotypes,
were valued for the intensity of tone that they enabled the photographer to realize, as well as for their
matte (rather than shiny) surfaces. The platinotype portrait of the Classics scholar, A. E. Housman,
was made around the time that he was writing his most famous volume of poems, *A Shropshire Lad*.

Sir Henry Irving (1838-1905)

ACTOR AND WRITER

A Visitor to the Rehearsal
ink over pencil (recto), pencil preparatory sketch (verso), [1893]
by Aubrey Beardsley (1872-1898)

Had Aubrey Beardsley lived beyond his short twenty-five years, there is little doubt that, like Charles Ricketts, he would have turned eventually to theatre design. He was enamored of the stage and of the extravagant personalities associated with it. In the very first issue of the *Yellow Book*—the Bodley Head magazine for which he served as art editor from 1894 until his firing in 1895, amidst the scandal of the Wilde trials—he published a drawing of the actress Mrs. Patrick Campbell, using the black-and-white print medium to turn one of his favorite performers into a flower, impossibly long and slim like a dark-headed daisy. But even earlier, Beardsley had been delighted to receive work from the *Pall Mall Budget*, which engaged him to produce topical scenes and images of celebrities, and he used that commission as an opportunity to record the images of idols such as Sir Henry Irving.

Sir Henry Irving (1838-1905)

painting, *Arrangement in Black, No. 3: Sir Henry Irving as Philip II of Spain*
(1876-1885), by James McNeill Whistler (1834-1903)
reproduced as frontispiece in Henry Irving, *The Drama: Addresses* (London, 1893)

For advocates of aesthetic book design, it was a sacred principle that the book must always present itself as a unified artistic object. Ideally, all of its decorations and illustrations would spring from the vision of a single individual and would be created specifically for that volume. Some commercial publishers tried to hold fast to this standard; Elkin Mathews's and John Lane's Bodley Head firm, for instance, eschewed the late Victorian fad for photographic frontispieces. But other presses realized the wisdom of giving the public what it wanted and of inveigling artists to allow their works—especially portraits of the authors or biographical subjects of a text—to be reproduced and inserted in volumes that the artists had not designed. That J. M. Whistler permitted his painting of Henry Irving to grace this collection of Irving's thoughts on the theatre is a testimony to his friendship with the book's publisher, William Heinemann. The painting itself represents one of the most important genres of late Victorian portraiture: the theatrical portrait, memorializing well-known male or female actors in their stage roles. Irving, the reigning theatrical figure of his generation, is in costume for *Queen Mary*, a drama in verse by Alfred, Lord Tennyson.

66

THE

D R A M A

ADDRESSES

BY

HENRY IRVING

LONDON
WILLIAM HEINEMANN
1893

Henry James (1843-1916)

NOVELIST AND SHORT STORY WRITER

lithograph, 1898
by Sir William Rothenstein (1872-1945)

Fittingly, William Rothenstein's portrait of Henry James was a work of delicate suggestions and empty spaces, for by the late 1890s, James had turned himself into the master (and was known to those who admired him as "The Master") of allusive and elusive prose. James, who had chosen to inhabit a gentlemanly English persona and who had much in his private life—from his American roots to his sexuality— that he did not wish to make the focus of public interest, had a horror of personal publicity. While sharing a number of Oscar Wilde's tastes, literary and otherwise, he was Wilde's antithesis when it came to self-promotion. With his contribution to the inaugural issue of the *Yellow Book*, "The Death of the Lion," James bearded the lion in its den. He produced a story that savaged the newly aggressive practices of the publishing world, which treated writers as commodities, and gave it to John Lane, whose Bodley Head firm was certainly among the worst violators of the sanctity of the privacy of authors.

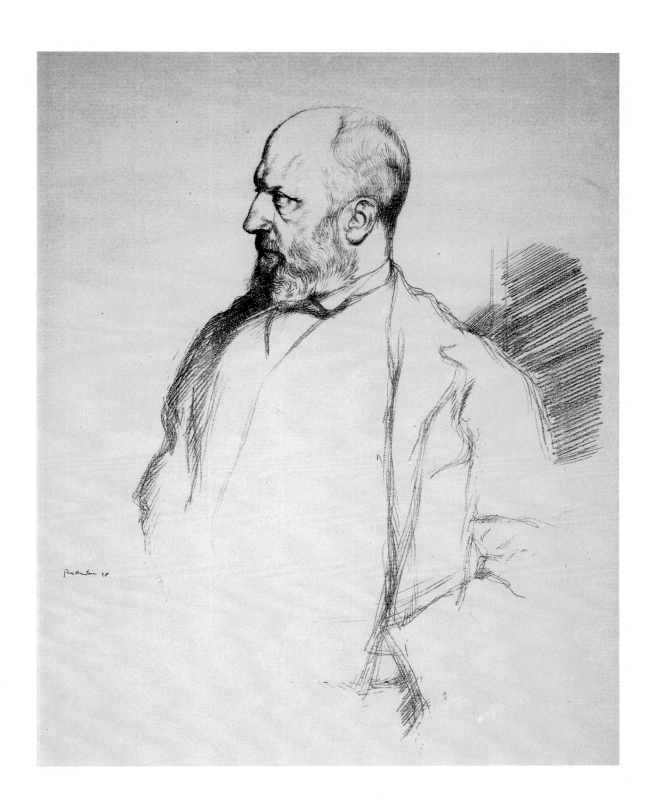

69

Rudyard Kipling (1865-1936)

NOVELIST, SHORT STORY WRITER, AND POET

Self-Portrait
pencil, [1890]
with accompanying autograph letter to Helen Bartlett Bridgman
24 June [1890]

The ironies surrounding Rudyard Kipling's career were almost limitless. Although he made his name as the voice of the working-class Cockney soldier raising hell in the farflung outposts of Her Majesty's Empire, he was actually an educated, Colonial journalist with genteel connections and even family ties to the bohemian world of the Pre-Raphaelites through the painter, Edward Burne-Jones. Audiences who snapped up his adventurous tales of India were nonplussed by photographs of the writer, which showed him to be not some strapping specimen of Victorian masculinity, but a studious-looking gentleman with a large, balding head, a rather silly moustache, and eyes that peered wonderingly through thick-lensed glasses. He looked less like a military man than an Oxford don. Lacking a photograph to send to the recipient of this letter, Kipling, who was the son of an art teacher, drew this image of himself. In it, he emphasized the same qualities of refinement and sensitivity of appearance that so puzzled contemporaries who expected him to resemble one of his fictional roughnecks from *Soldiers Three*.

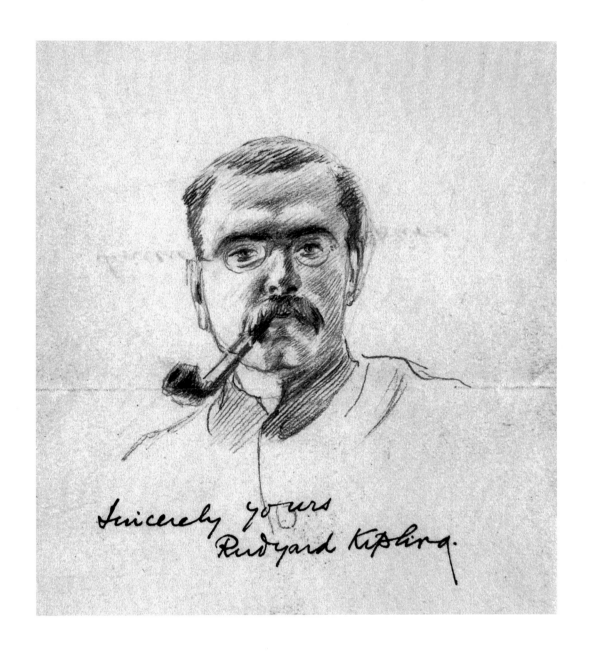

Sincerely yours
Rudyard Kipling.

Richard Le Gallienne (1867-1947)
POET AND ESSAYIST

> bookplate of Richard Le Gallienne
> wood engraving, [ca. 1892-1894]
> by Alan Wright (fl. 1889-1925)
> tipped in Richard Le Gallienne, *Volumes in Folio* (London, 1889)

During the final decades of the century, the available media through which portraits could be disseminated were seemingly endless and so, too, were the potential variations in size. Portraits could be larger-than-life on advertising posters, which increasingly featured theatrical personalities and celebrities, either photographed or drawn. Such large-scale images were meant for public consumption and usually displayed in urban spaces. But the new craze for bookplates and for bookplate collecting also reduced representations of individuals to miniature size and brought them into private, domestic settings. Personalized bookplates often depicted the owners who commissioned them. The artist Alan Wright's design for Richard Le Gallienne was unusual for being a sort of triple portrait—of the poet, his wife Mildred (whose life was tragically short), and his beloved collection of old and rare books.

Richard Le Gallienne (1867-1947)

Mr. Richard Le Gallienne
ink and wash, [ca. 1900]
by Sir Max Beerbohm (1872-1956)

To Max Beerbohm, Richard Le Gallienne was a figure with his head in the clouds—clouds, that is, of his own hair. The cultivation of an appearance of Shelleyan grace and delicacy was deliberate, a result of Le Gallienne having seen and heard Oscar Wilde lecture in 1883. For the young poet, whose social origins were undistinguished (the French article in his surname was an addition meant to counter any traces of Liverpool left in his voice), the sight of Wilde, with his foppish clothes and flowing locks, proved a revelation. He took the Wildean model of what "genius" looked like and improved upon it, for unlike Wilde, who was physically ungainly and whose clothing lent him a distinction his heavy face otherwise lacked, Le Gallienne was blessed with androgynous beauty. He realized quickly, too, that his was a face that photographed nicely, and he made sure that images of it circulated throughout the literary world. Joining up early in his career with John Lane and Elkin Mathews to become one of their first Bodley Head authors (and then remaining with Lane's firm after the two business partners split), he was entirely in sympathy with Lane's impulse to merge the field of publishing with what we now call public relations.

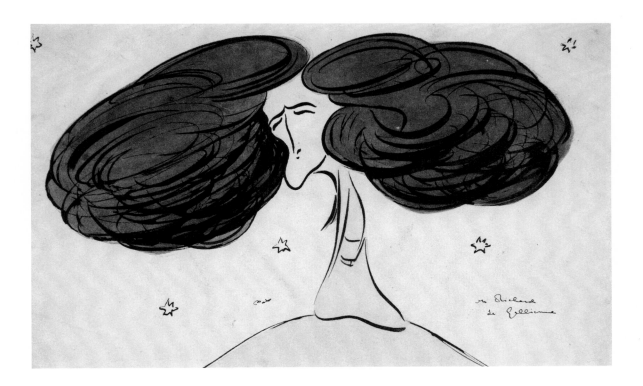

Caroline Blanche, Lady Lindsay (née Fitzroy) (1844-1912)
POET AND ARTIST

pencil, 1873
by George Howard, Ninth Earl of Carlisle (1843-1911)

For his portraits of creative figures, George Howard liked to pose his sitters at work or, at least, brandishing props associated with their achievements. His pencil sketch of Edward Burne-Jones shows the latter in the midst of painting; his drawing of Lady Lindsay depicts her holding a violin, for she was an accomplished amateur musician. But in fact, Howard had his choice among three different kinds of instruments to place within the composition. He could have represented her instead as wielding a phallic-looking pen, for she was an aspiring writer who, at the end of the next decade, would begin publishing poetry and fiction; or he could have drawn her as a rival visual artist, with brush in hand, for she was also gifted as a painter. (After founding the Grosvenor Gallery with her husband, Sir Coutts Lindsay, she began exhibiting her work at that famous London center of the aesthetic movement.) To show her with a violin, however, was perhaps the most daring decision. Unlike pianos, which were considered to be instruments appropriate for ladies and associated with private performances in the home, violins suggested the *louche* world of public recitals. Anything that might put a woman on view and potentially on a stage (whether or not the stage of a theatre) was looked at with suspicion, if not hostility, as an affront to the notion that her rightful place was in the domestic sphere.

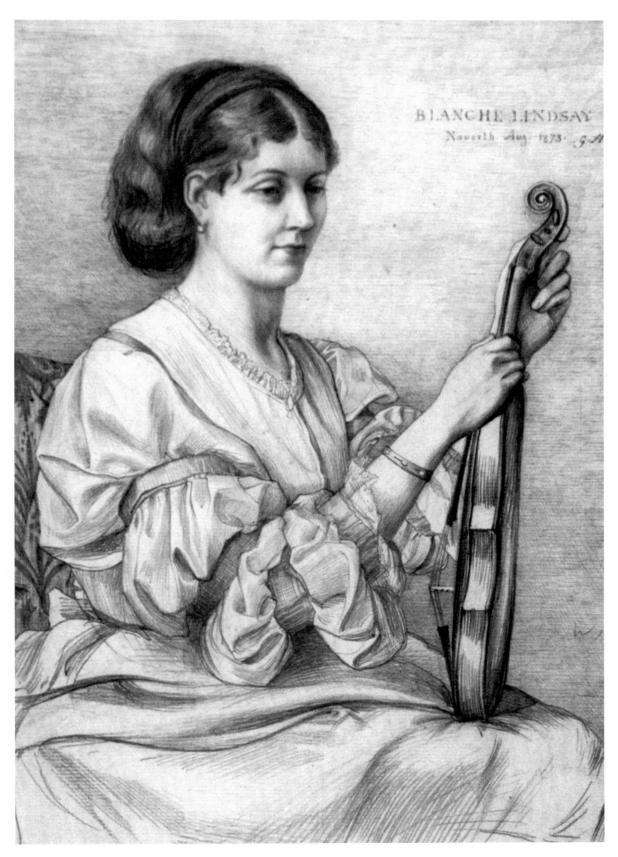

BLANCHE LINDSAY
Nazarth Aug 1873 G H

75

Violet Manners (née Lindsay), *Duchess of Rutland* (1856-1937)

ARTIST

The Marchioness of Granby
lithograph, 1897
by Sir William Rothenstein (1872-1945)

William Rothenstein's image of the Marchioness of Granby offers an interesting contrast to his lithograph of Alice Meynell, although both were done at about the same time for his book, *English Portraits*. The detailed, three-quarter-view representation of the head of "Mrs. Meynell" (as she is identified in the volume) allows full access to her face and especially to her eyes. The spectator is invited to interpret her expression and thus, presumably, to read the female poet's thoughts. But Rothenstein's version of the Marchioness in profile, with eyelids lowered, was the most discreet portrait possible—so unrevealing of personality as almost not to constitute a portrait at all. There were a number of reasons for this rather excessive degree of respect for the sitter's privacy. She was an

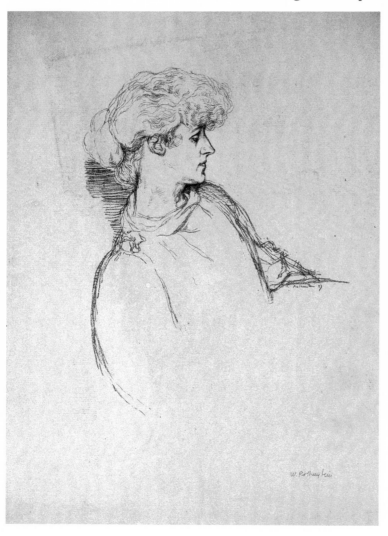

accomplished artist herself—more than that, a portraitist, and thus a worker in Rothenstein's own field. She was a slightly older woman and, of course, a lady, which meant that she was owed deference from a young man, especially from one who aspired to be a gentleman. But above all else, she was a titled aristocrat with powerful friends in the world of the arts, and Rothenstein, whose professional career was still in its early stages, would have been a fool to risk displeasing her.

Phil May (1864-1903)

CARTOONIST AND ILLUSTRATOR

Self-Portrait
ink, 1901

If Max Beerbohm was the epitome of the caricaturist-as-gentleman, cultivating a persona that was fastidiously aloof and choosing subjects mainly from the world of high art, Phil May was his complementary opposite. Employed for much of the 1890s as a cartoonist for *Punch*, he delivered a series of highly popular comic sketches of London life, favoring as his subjects music-hall performers, Cockneys, street urchins, sporting figures, and the occasional "toff." He could take nothing seriously—neither his own appearance nor the traditions associated with artists' self-representations. His images of himself exaggerated the loudness of the already quite loud checked suits that he fancied. So, too, May toyed irreverently with the convention of male painters depicting themselves with phallic paintbrushes in hand, a reference to masculine potency as the source of their creativity. For this particular comic self-portrait, May had enormous phallic props seemingly jutting from every available orifice.

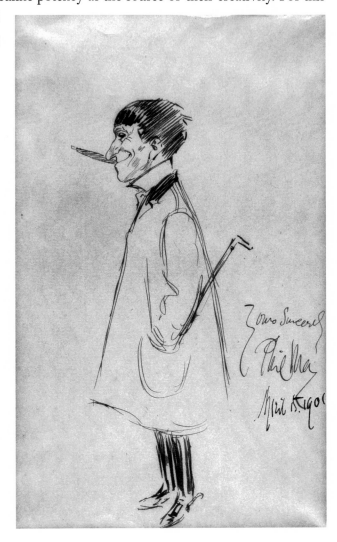

George Meredith (1828-1909)

NOVELIST AND POET

photograph, platinotype, [1890]
by Frederick Hollyer (1837-1933)

By the 1890s, George Meredith had labored in obscurity for many decades—years during which he was better known as a reader for the publishing firm of Chapman and Hall than as a poet or writer of fiction and essays—and had won fame at last. His reward was not merely to be celebrated as a great English author, but as a kind of icon of authorship itself. When the late Victorian public thought of what a writer was supposed to look like (and, of course, the image that came to mind usually bore the face of a man), his was the ideal head: strong-featured, craggy, noble, and resolute. This was especially true after the death of Tennyson in 1892, when Meredith assumed not the official mantle of poet laureate, but the unofficial title of the Grand Old Man of Letters. His publishers Ward, Lock, Bowden & Co. did what they could to capitalize upon this phenomenon by reissuing his *The Tragic Comedians* "With a Photogravure Portrait of the Author" and also by advertising the large paper edition of *The Tale of Chloe* (1895) as "containing a recent photogravure portrait of Mr. Meredith." It was a sign of how important Meredith had become, not merely as a writer but as a camera subject, that the image was done by the distinguished photographer, Frederick Hollyer.

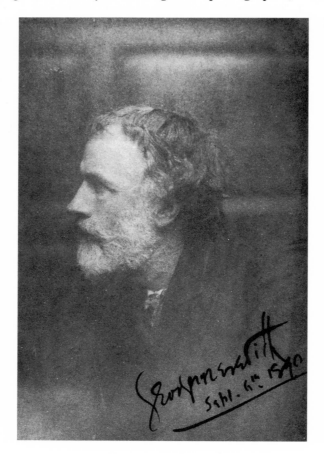

Alice Meynell (1847-1922)
POET AND CRITIC

lithograph, 1897
by Sir William Rothenstein (1872-1945)
from William Rothenstein, *English Portraits: A Series of Lithographed Drawings* (London, 1898)

Alice Meynell was all that a Victorian woman poet was supposed to be, except that Victorian women were not supposed to be poets at all. As a consequence, her own career never quite reached the heights of the male versifiers, such as George Meredith and Francis Thompson, who hovered around her adoringly. She distinguished herself not merely as a writer of devotional poetry (while in her twenties, she converted to Roman Catholicism), but as a critic, especially in the fields of literature and the visual arts. Yet she remained more influential as a hostess and as a friend and supporter of her fellow authors than as a creative figure in her own right, and her work rarely received credit for being a shaping force on others. Her contemporaries tended to focus instead upon her ability to conform so perfectly to the late-nineteenth-century feminine ideal. They praised Meynell as a wife and mother and noted admiringly the quality of grave and beautiful spirituality that William Rothenstein captured in this lithograph for his volume *English Portraits*.

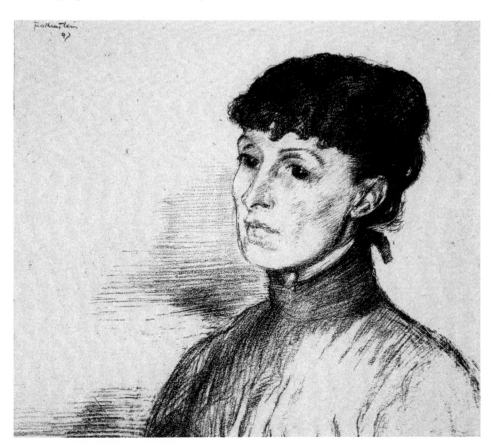

T. [Thomas] Sturge Moore (1870-1944)
POET AND ARTIST

The Modeller
lithograph, [1891]
by Charles Haslewood Shannon (1863-1937)

Charles Shannon's title for this lithograph, *The Modeller*, seems wholly appropriate, for it is in some ways a representation of a creative activity, even more than of an individual. The usual focus of late Victorian portraiture on psychological revelation has been subordinated to the desire to show that personal identity plays second fiddle in importance to the practice of art itself. Shannon's image of his beloved partner, Charles Ricketts (*The Wood-Engraver*), is in the same genre, emphasizing the primacy of the work that is being accomplished, as well as the impossibility of knowing the subject apart from his art. That Shannon could also excel at more conventional modes of portraiture is clear from his 1896 image of the same sitter, *T. Sturge Moore in a Cloak*, which shows Moore *sans* props, his head raised high in profile, and with a rather disdainful expression.

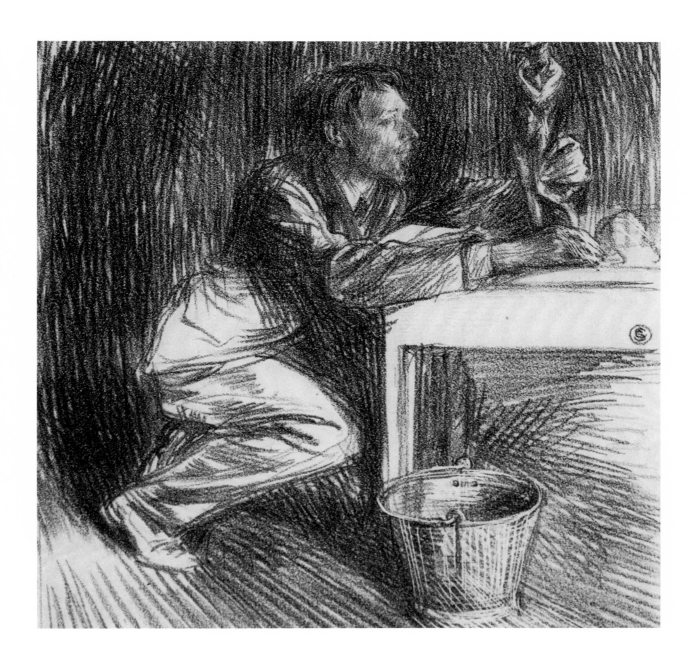

Jane Morris (1840-1914)

EMBROIDERER AND BINDING DESIGNER

Mrs. William Morris
pencil, [1870]
by Dante Gabriel Rossetti (1828-1882)

To a Victorian observer used to reading visual signs for their social meanings, D. G. Rossetti's depiction of Jane Morris asleep would have been as much an announcement of his adulterous intimacy with her as if he had drawn her naked. No man was supposed to be alone with the wife of another—even the wife of his close friend, William Morris—under such unguarded circumstances. Thus, this pencil drawing was in a sense a double portrait. It functioned as a record of the beauty of Jane Morris, who was both a living art object for the Pre-Raphaelite circle and a creative designer herself, active in the arts-and-crafts movement; yet it was just as much a self-portrait, for it also revealed the scandalous secret of the artist's illicit passion for her.

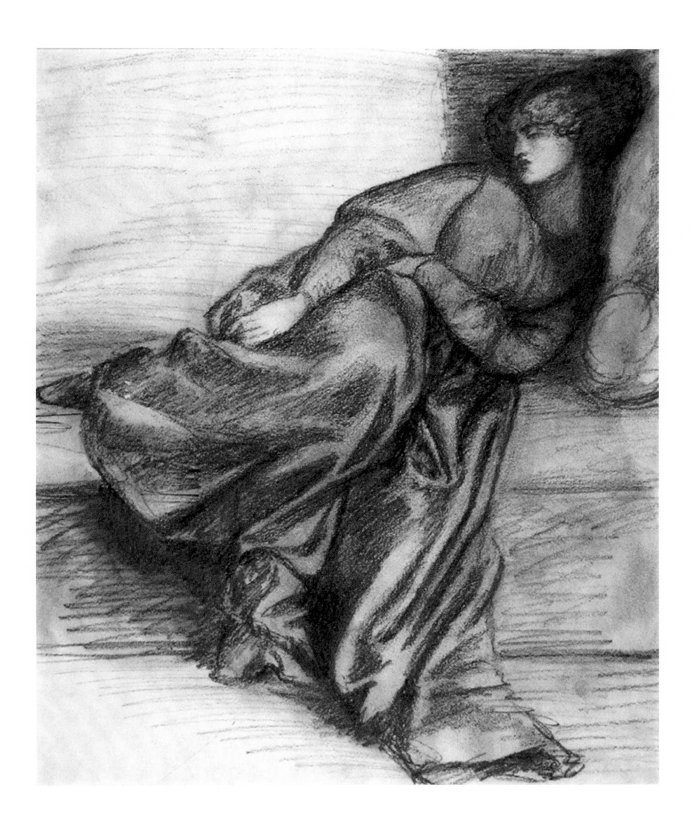

William Morris (1834-1896)

POET, DESIGNER, AND PRINTER

with

May Morris (1862-1938)

DESIGNER AND CRAFTSPERSON

and members of the Hammersmith Branch of the Socialist League

> photograph, albumen, [1885-1889]
> attributed to Frederick Hollyer (1837-1933)

Group portraits could serve a variety of private ends. But they often performed a documentary function as well, especially when the group, whether a graduating class or a sporting team, had an institutional or public dimension. Late Victorian political organizations, too, took particular pride in recording images of their members. This was true even in cases where being identified as participants in radical activitism opened up members to harassment by local authorities. The metropolitan police officials were especially keen to block the activities and disrupt the public meetings of socialist groups, seeing the foment of new ideas among London's poor and working classes as a threat to the status quo. Such organizations were also perceived, quite rightly, as dangers to the stability of gender rules and roles, for they encouraged women and men to mix and to converse without restraint, while discussing such daring topics as "free unions" (i.e., heterosexual partnerships without marriage). We can see the presence of women as an important part of the Hammersmith Branch of the Socialist League, which was founded by William Morris at Kelmscott House and which included his daughters, May and Jenny Morris, as members. This group image is believed to be the work of the great photographer Frederick Hollyer, who belonged to the Linked Ring Brotherhood (a circle of photographers dedicated to

advancing their medium as an art form) and who also worked with Morris's dear friend and fellow Pre-Raphaelite, Edward Burne-Jones, to create photographic reproductions of the latter's paintings.

E. [Edith] Nesbit (1858-1924)
POET AND NOVELIST

photograph, silver gelatin, with sepia toning, [ca. 1901]

Photographs of E. Nesbit often showed her looking somewhat haggard, or at least melancholy. This was hardly surprising, given the degree of financial pressure under which she labored while supporting not only her husband (the journalist Hubert Bland) and their children, but his mistresses and the children they bore him. A New Woman and a founding member of the Fabian Society, she did not need divided skirts or other forms of "rational dress" to announce her feminist or socialist allegiances, for she demonstrated her adherence to radical principles through the care and help that she offered selflessly to everyone around her, regardless of their gender, class, or circumstances. Her literary career began in the 1880s with poetry, but that eventually proved a limiting genre for her (as well as a lower-paying one), and she moved rapidly into prose. Although she is remembered today only for her wildly popular children's fiction, her short stories of the 1890s—particularly those in her 1896 Keynotes Series volume for the Bodley Head firm, *In Homespun*—were moving, sometimes comical tales for adults about working-class women trying to achieve independence and dignity.

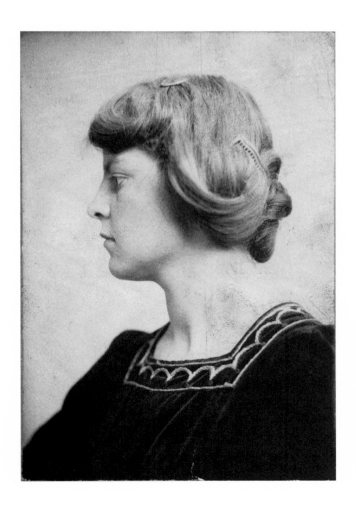

Ida Nettleship (1877-1907)

ARTIST

Ida, Standing Before a Fireplace
pencil, [ca. 1899-1900]
by Augustus John (1878-1961)

The daughter of Jack Nettleship, a minor artist who supported and encouraged her in the pursuit of a vocation as a painter, Ida Nettleship managed to avoid at least one of the obstacles—parental opposition—that often kept Victorian women artists from succeeding. She became one of the star pupils of the Slade School in the late 1890s, a protegée of J. M. Whistler's, and a valued member of a circle of female artists that included Edna Clarke Hall and Gwen John. In 1900, she married the latter's brother, the painter Augustus John. His portrait sketch of her, however, omits any visual reference to her talents or accomplishments. It is instead squarely in the tradition of male artists' renderings of female models as sexual possessions. Ida Nettleship gives the spectator a coyly erotic, come-hither glance, and although she is depicted in a domestic setting, her own easel and brushes are nowhere to be seen.

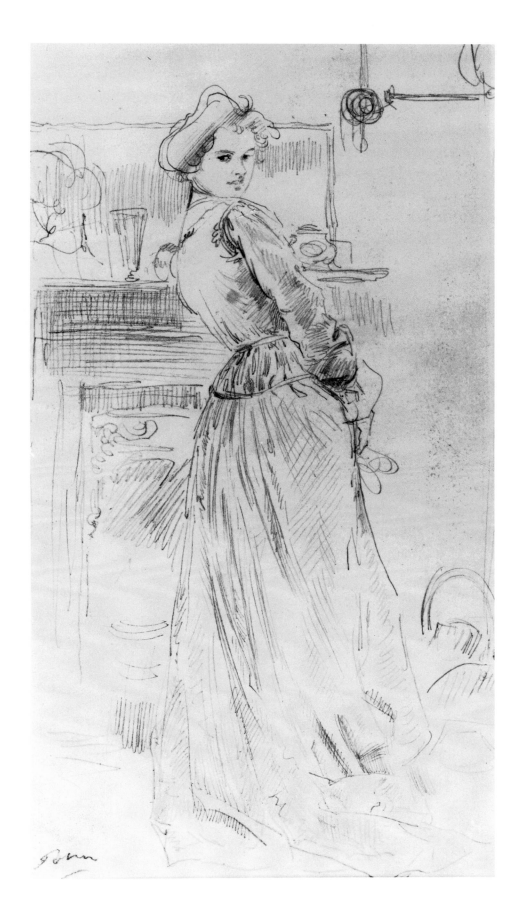

Walter Pater (1839-1894)

ESSAYIST AND NOVELIST

lithograph, 1894
by Sir William Rothenstein (1872-1945)
in William Rothenstein, *Oxford Characters: Twenty-four Lithographs by Will
Rothenstein, with Text by F. York Powell, and Others* (London, 1896)

To place a portrait of Walter Pater among his *Oxford Characters* was actually quite a controversial decision on William Rothenstein's part. Pater's relationship with the university where he was a professor had long been a troubled one, and there were some at Oxford who were unhappy about having the institution associated with an aesthete and an advocate of "Greek love" (usually assumed by the Victorians to be the educated classes' code term for homosexuality). Rothenstein's image, however, was hardly that of a dangerous hedonist, encouraging young men to burn with hard, gemlike flames. On the contrary, it presented Pater as sober, circumspect, carefully groomed, and retiring— as in truth he was, rather to a fault. Indeed, several years later, Max Beerbohm would poke posthumous fun at Pater's disciplined bearing, caricaturing the author of *Studies in the History of the Renaissance*, with its scandalous conclusion defending art for art's sake, as a stuffy figure who seemed to be on his way to a board meeting at a bank.

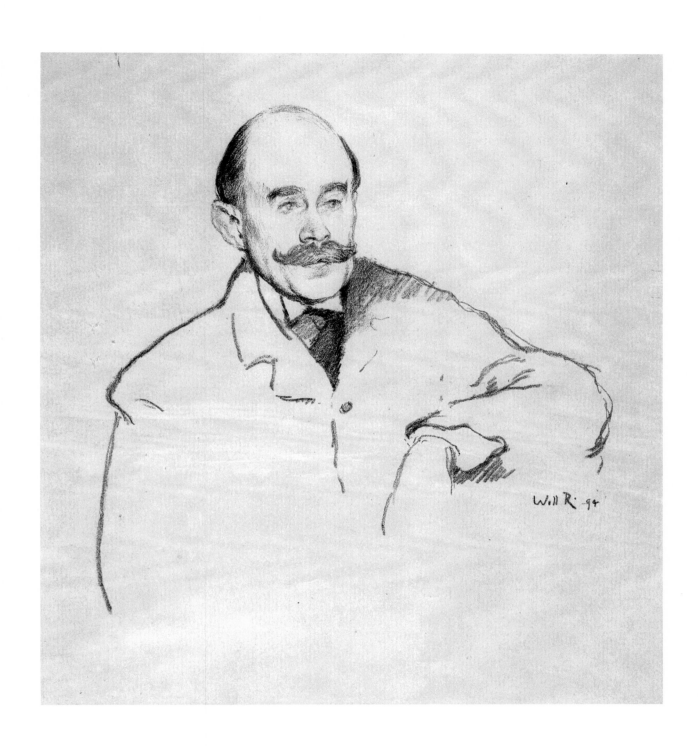

89

Joseph Pennell (1857-1926)

ARTIST AND WRITER

Letter L (Self-Portrait of the Artist, Seated)
ink, [ca. 1890-1900]

At the end of the nineteenth century, Britannia may have ruled the waves, but it had no monopoly on London's picture galleries. The so-called British art scene was in fact composed of a multitude of influences, thanks not only to English painters who trained in Paris, but to artists who came from across the Channel or across the Atlantic. Some, such as Lucien Pissarro, were French; others were American, such as J. M. Whistler and his disciple from Pennsylvania, Joseph Pennell. A journalist (like his wife, Elizabeth Robins Pennell), as well as an artist, Pennell is not usually thought of now as a portraitist, and this amusing little caricature of himself sketching outdoors, observed by a child—part of a decorative initial letter executed for the *Century Magazine*—is something of an anomaly in his *oeuvre*. It is anomalous for another reason, too, for Pennell, who became well known for his etchings of landscapes and of church architecture, rarely showed this lighthearted side in public. What he displayed instead, in the early 1890s, was a streak of vicious anti-Semitism masquerading as ethnographic interest. In his 1892 volume, *The Jew at Home: Impressions of a Summer and Autumn Spent with Him*, Pennell offered an expanded version of articles that he had published in the *English Illustrated Magazine* in 1891, including several portrait sketches of Austrian, Hungarian, Polish, and Russian Jews as loathesome physical types. The book was, in a sense, more of a self-portrait than an actual record of travels—a portrait of the artist as an unrepentant bigot.

Lucien Pissarro (1863-1944)

ARTIST AND PRINTER

lithograph, [1895]
by Charles Haslewood Shannon (1863-1937)

Living in London in the early 1890s, Lucien Pissarro (son of the French impressionist artist, Camille Pissarro) attempted to forge a career independent of his father, a task that grew easier once he discovered wood engraving as an attractive alternative to oil painting as a medium. He was encouraged in his efforts at printmaking by his new English friends, the inseparable couple Charles Ricketts and Charles Shannon, who published some of his work in their magazine, the *Dial*, and who also welcomed him into their social circle, which included Oscar Wilde, Max Beerbohm, and William Rothenstein. By the end of the decade, the relationship between Pissarro and Ricketts and Shannon would cool somewhat, over differences in artistic philosophy. This portrait of Pissarro from 1895, however, records a moment when the two founders of the Vale Press still saw their French associate in printing and book illustration as a glamorously dark and exotic-looking asset in their professional and personal lives.

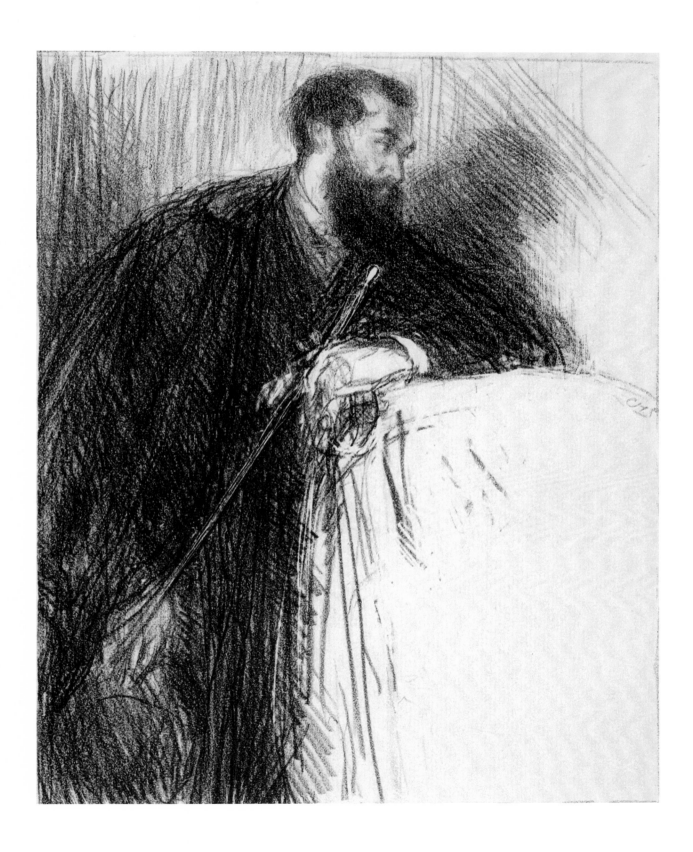

93

Charles de Sousy Ricketts (1866-1931)

ARTIST AND DESIGNER

The Wood-Engraver
lithograph, [1894]
by Charles Haslewood Shannon (1863-1937)

The women who became Michael Field embodied one way of working as a same-sex couple, where both partners were engaged in the identical area of the arts: they produced their literary texts collaboratively and, as their joint portrait in this volume demonstrates, functioned as an indissoluble unit. Their friends Charles Ricketts and Charles Shannon, however, chose an alternative approach, one more in keeping with stereotypically masculine ideals of independence. With both partners equally gifted in the visual arts, Ricketts and Shannon divvied up the available pursuits. While sharing the responsibility for some ventures, such as their journal the *Dial* and their publishing firm, the Vale Press, each half of the couple staked out different territory as his own. Ricketts became a decorative artist, achieving tremendous success in book design and, for several years, using that success to finance Shannon's efforts to train as a painter. Shannon, meanwhile, took the high art road and, whether working in oils or producing lithographs, specialized in portraiture.

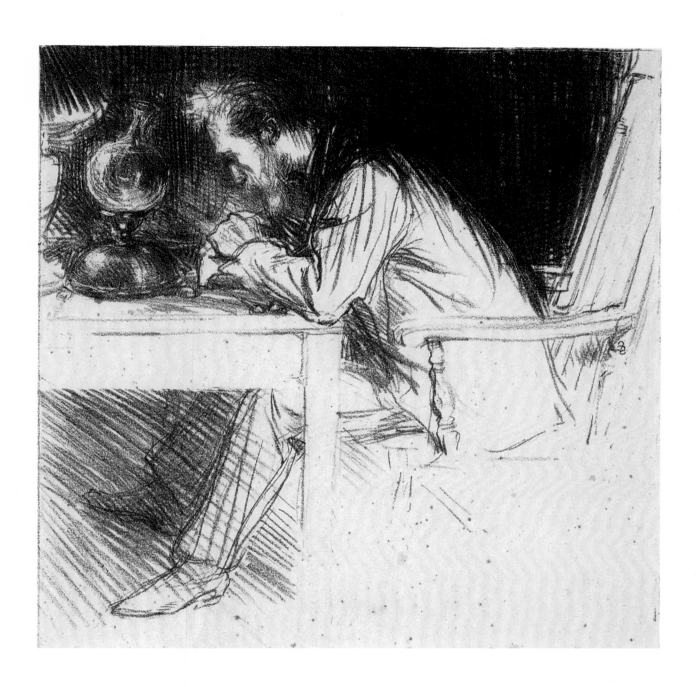

95

W. [Walford] Graham Robertson (1866-1948)
ARTIST, ILLUSTRATOR, AND PLAYWRIGHT

photograph, matte collodion cabinet card, [early 1890s]
by H&R Stiles, London

Technological improvements to the camera, including the possibility of faster shutter speeds, offered late Victorian studio photographers greater freedom in the kinds of images they could record. It also allowed their sitters more leeway in choosing poses and even props, especially when those props were animate. Thus, Graham Robertson was able to have this double portrait made, capturing a moment when one of his beloved pet sheepdogs turned toward the camera its soulful gaze. Although Robertson was happy to play a supporting role in this image, J. S. Sargent, not surprisingly, decided to reverse the dynamic in his own famous version of this pairing, executed around the same time (i. e., when Robertson was in his mid-twenties). Sargent's painting depicts Robertson, the consummate dandy, erect in the foreground and a dog sprawled in the background, fast asleep.

W. Graham Robertson (1866-1948)

with members of the Loony Club, including

H. J. [Henry Justice] Ford (1860-1940)
ILLUSTRATOR

J. W. [John William] Mackail (1859-1945)
CLASSICIST, LITERARY SCHOLAR, AND POET

photograph, albumen, [ca. 1890]

Photographers and sitters alike recognized early on the potential for introducing to the medium of portrait photography dress-up games and other forms of play. Julia Margaret Cameron had indulged this sort of theatrical fancy, decking out female friends and relations as Shakespearean heroines, Pre-Raphaelite maidens, and biblical queens, while turning even the seemingly dour Tennyson into the image of a "Dirty Monk." For Graham Robertson, who was both a serious portrait painter (his early sitters included actresses such as Aubrey Beardsley's sister, Mabel, and Ellen Terry) and a man with a whimsical bent, it was inevitable that the same impulse that made him fill sketchbooks with comic drawings and self-caricatures would also lead him to record for posterity the hilarious gatherings he enjoyed with friends. In this photograph, the woodland spirits crowned with flowers are members of the circle that Robertson dubbed the "Loony Club," with himself as president—a group that included the illustrator Henry Justice Ford, the literary scholar J. W. Mackail, and Mackail's wife, Margaret, daughter of the artist Edward Burne-Jones.

Dante Gabriel Rossetti (1828-1882)

PAINTER AND POET

photograph, albumen carte-de-visite, [1862-1863]
by W. and D. Downey, London
in Algernon Charles Swinburne's photograph album

Assembling albums was a pastime of the middle classes throughout the Victorian period. Early in the nineteenth century, this pursuit tended to divide along gender lines. Ladies collected souvenirs and pasted into keepsake albums such diverse objects as pressed flowers, dance cards, locks of hair, or favorite stanzas of verse clipped from newspapers, while gentlemen might maintain albums of cuttings about a favorite hobby or sport, such as horseracing or boxing. But by the second half of the century, the passion for acquiring and preserving photographs touched men and women equally, as technological advances in the production and printing of the images and the proliferation of cameras made the new art increasingly part of daily life. Today an album such as this one, however, put together by Algernon Swinburne, serves as more than merely a document of the Victorian age; it is also an

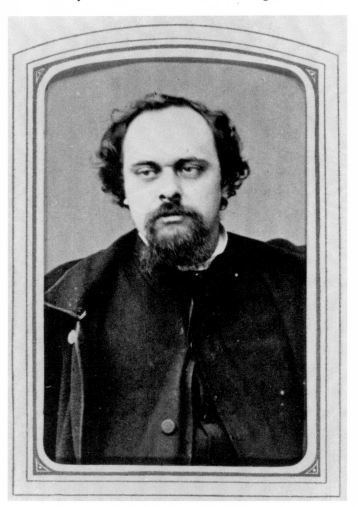

invaluable record of a particular intellectual circle and of the literary influences upon the poet and critic. Swinburne kept not only family pictures, but images (including many carte-de-visite photographs) of his English or American friends, such as the painters Ford Madox Brown and J. M. Whistler; the traveler and author Sir Richard Burton and his wife, Isabel, Lady Burton; and, of course, his Pre-Raphaelite hero and mentor, D. G. Rossetti. Yet he was also part of a select group of late Victorian thinkers—figures such as George Eliot and her partner, George Henry Lewes—who sought to know and to maintain relations with their European counterparts, especially in Germany or France. Thus, one of the other famous heads displayed in this album belongs to the novelist Victor Hugo.

Sir William Rothenstein (1872-1945)

Self-Portrait, Aged 17
charcoal and white chalk on brown paper, 1889

William Rothenstein was best known as a portrait artist, specializing in images of British writers, artists, scholars, and intellectuals (and leaving it to J. S. Sargent to corner the more lucrative market in transatlantic business tycoons and their expensively over-decorated wives and daughters). We find him at the young age of nineteen already practicing for his future career with this sensitive, yet unglamorized, image of himself—doughy cheeks, spectacles, and all. What this sober vision fails to suggest, however, is the great attraction Rothenstein had felt since his days as a schoolboy to caricature and cartooning. Even before his fateful meeting with Max Beerbohm, he was a fan of such late Victorian comic artists as Linley Sambourne, John Tenniel, and especially Harry Furniss. Indeed, in his two-volume autobiography, *Men and Memories: A History of the Arts, 1872–1922* (1931–1932), he would reveal that, at the age of fifteen, he had sent a group of his own attempts at caricature to Furniss, but his idol's response was not enthusiastic.

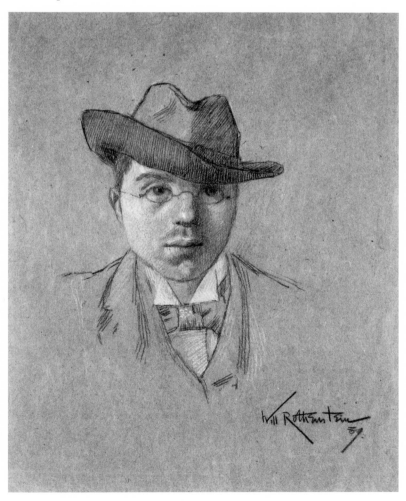

Sir William Rothenstein (1872-1945)

and others, including

Aubrey Beardsley (1872-1989)

Charles Furse (1868-1904)
ARTIST

George Moore (1852-1933)
NOVELIST

Sir Arthur Wing Pinero (1855-1934)
PLAYWRIGHT

Archibald Philip Primrose, Fifth Earl of Rosebery (1847-1929)
STATESMAN AND AUTHOR

Oscar Wilde (1854-1900)
POET, CRITIC, NOVELIST, AND PLAYWRIGHT

> *Will Rothenstein Laying Down the Law*
> ink, colored chalks, and wash, [ca. 1895]
> by Sir Max Beerbohm (1872-1956)

As a dandy and an aesthete, Max Beerbohm believed fervently in the value of self-contradiction and of holding fast to principles that were seemingly incompatible and irreconcilable, a philosophy which he brought to the practice of caricature. To admire someone meant that one must also seek out and ridicule the unlovely sides of one's object of admiration, and there was no one whom Beerbohm admired more than William Rothenstein. Thus, it was only to be expected that Beerbohm would make his dear friend the subject of numerous visual lampoons—in this case, one of his rare composite caricatures, in which the image is made up of a number of separate scenes occurring at different moments, but viewed simultaneously (a technique that anticipates some of the uses of split screen effects in the early cinema). To Beerhbohm's credit, his caricatures of Rothenstein never drew upon contemporary racial stereotypes of Jews as hawk-nosed or sharp-eyed predators. Instead, he depicted Rothenstein as an absurdly tiny, childlike dandy moving among the great and famous with a preternatural self-confidence for someone still in his early twenties. In this caricature, the artist feels free to lecture everyone from George Moore, the successful author of *Esther Waters* (1894), to Oscar Wilde (at the height of his fame as a public figure and just before his scandalous fall), to the heir to Britain's throne about the very matters on which they were most expert.

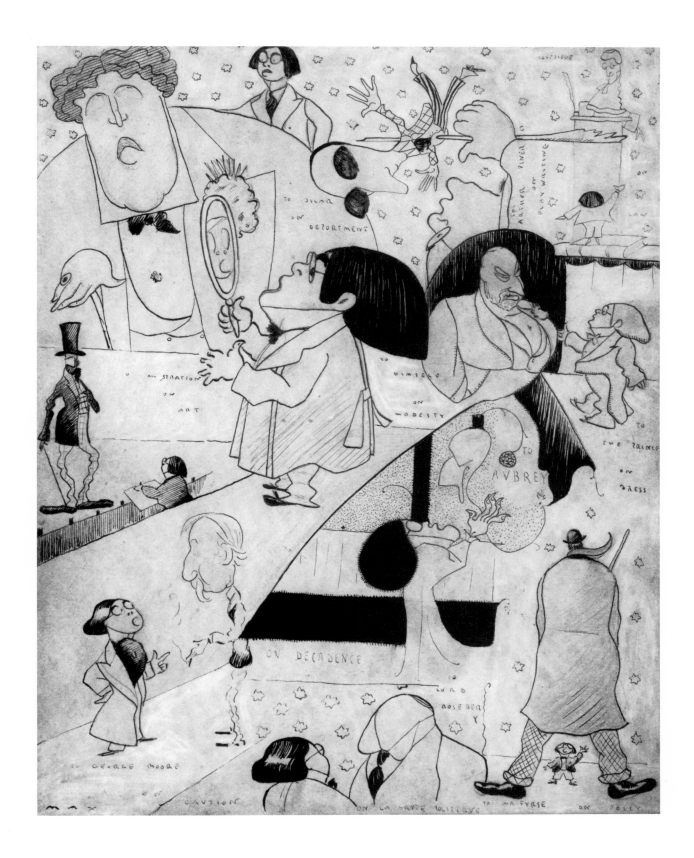

John Singer Sargent (1856-1925)

PAINTER

lithograph, [1897]
by Sir William Rothenstein (1872-1945)
from William Rothenstien, *English Portraits: A Series of Lithographed Drawings* (London, 1898)

No clearer evidence exists of the late Victorian craze for collecting and studying the faces of the famous than the 1898 volume, *English Portraits: A Series of Lithographed Drawings*. That Grant Richards, a start-up publisher working with little capital, would have commissioned this book, given it a sumptuous format, and produced it in an edition limited to 750 copies, attests to his confidence in the market for such material. To supply the images of contemporary critics, artists, actresses, and others prominent in the cultural world, he engaged William Rothenstein, who had already enjoyed success two years earlier with *Oxford Characters*, a similar venture issued by one of Richards's chief rivals, John Lane. Each lithograph was accompanied by what was called a brief "biographical notice"—less a factual account of the subject than an impressionistic musing, roughly the length of a modern interpretative label for a museum exhibition. Among the authors of these texts were William Archer, Max Beerbohm, and John Gray. So incestuous was the production of this volume that some of the same celebrities appeared in it both as writers of notices and as sitters for Rothenstein's lithographs. But the volume reached the height of insularity with Rothenstein's portrait of another professional portraitist, John Singer Sargent. As if, however, to announce his difference from this artist working in precisely the same field, Rothenstein used the image to emphasize methods of representation as far as possible from those associated with Sargent. Thus, he presented Sargent in a way that would seem spontaneous and unstudied, looking the very antithesis of Sargent's own carefully posed, formal portraits of American and British belles and Captains of Industry. Indeed, Rothenstein's Sargent appears almost to have been caught unawares and captured against his will by his fellow "lion hunter," with a cigarette still dangling from his lips and an expression of wariness and defensiveness in his eyes.

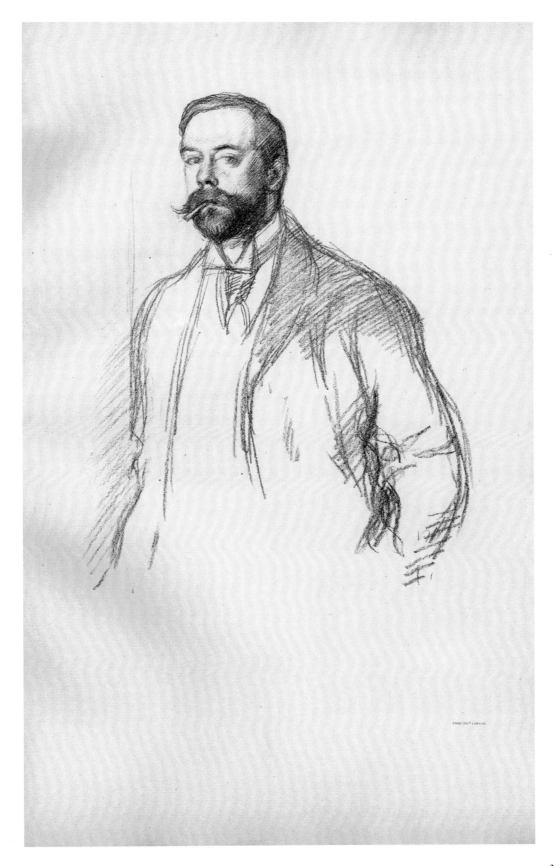

103

Olive Schreiner (1855-1920)

NOVELIST, AUTHOR OF *The Story of an African Farm* (1883)

photograph, reproduced as frontispiece in Olive Schreiner, *Dreams*
(London, 1891)

Who was Ralph Iron? In 1883, literary London burned to know the answer to that question. The pseudonymous author had published not only one of the first novels about South African colonial life, but one of the strongest indictments ever to have appeared in fiction of the Victorian gender system as an oppressive and destructive institution. It was a work, moreover, that would signal the emergence of late Victorian feminists as uncompromising New Women. By 1891, however, when the collection of socialist allegories called *Dreams* appeared, everyone in England knew that Ralph Iron was Olive Schreiner. Her publisher, T. Fisher Unwin, no longer needed to satisfy the public's curiosity about her identity, but definitely saw a market in appealing to its interest in what such a fire-breathing radical might look like. Unwin, therefore, took advantage of technological advances that made the reproduction of photographs a cheap and easy process and, like many publishers of the day, let

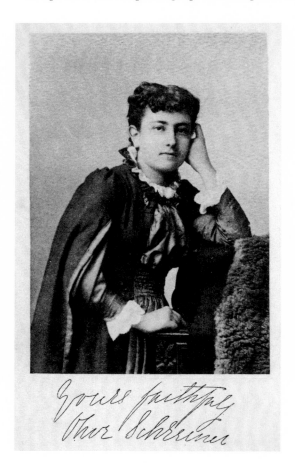

a studio portrait of the author serve as frontispiece to the volume. Not surprisingly, the image chosen was one that even middle-class bookbuyers would find unexceptionable, for it depicted the author as a seemingly respectable and ladylike figure, decorously clothed in bourgeois dress and with her head coiffed in feminine curls.

George Bernard Shaw (1856-1950)
PLAYWRIGHT

photograph, silver gelatin, [1893]
by Sir Emery Walker (1851-1933)

Toward the end of his long life, Shaw allowed himself to be filmed and recorded giving a little lecture for the newsreel camera about how audiences could be manipulated by tricks of lighting and expression on the human face. In that demonstration, he showed how easy it was for a politician, for instance, to present himself as a grave and serious thinker, merely by lowering his brows and positioning parts of his face in the shadow. Shaw's many years of experience in the theatre had, of course, made him conscious of such effects. But so, too, had his avid curiosity about photography—an interest which began in the late nineteenth century and never lessened. Shaw learned early on to take pictures himself, especially as photography became increasingly available to amateurs through the proliferation of cheaper, lighter cameras that allowed the kinds of spontaneous images called snapshots. This candid shot of Shaw, however, was taken by his socialist compatriot, the artist and engraver Emery Walker, who was also a friend of William Morris.

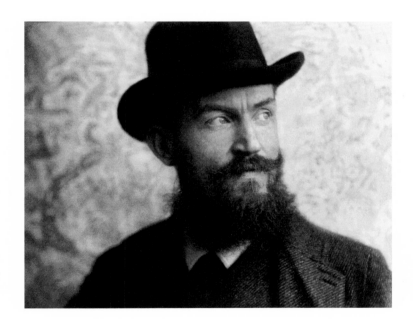

George Bernard Shaw (1856-1950)

lithograph, 1897
by Sir William Rothenstein (1872-1945)
from William Rothenstein, *English Portraits: A Series of Lithographed Drawings* (London, 1898)

G. B. Shaw learned from the example of his Irish compatriot, Oscar Wilde, that the road to success in England was paved with cloth. It was not enough merely to affect a suitable persona; an artist who believed that he had nothing to declare but his genius had to announce that fact while wearing an idiosyncratic outfit. Wilde's garb of choice in the 1880s was an aesthetic costume of silk, furs, and velvet. Shaw settled instead upon sturdy, no-nonsense Jaeger woolens, which enhanced the reputation he wished to develop as a radical thinker who hated bourgeois materialism and as a socialist speaking plain truths to and about the oppressed. (It did not hurt, of course, that a thick tweed suit was also cheaper to buy and maintain, for the 1880s were empty years for Shaw's pockets.) Shaw treated facial hair, too, as a contribution to his desired image, cultivating a pointed beard and moustache that were at once dandiacal and diabolical. In later years, Max Beerbohm would seize upon this latter aspect of Shaw's appearance and caricature him as a grinning devil with a long, snaky tail and horns.

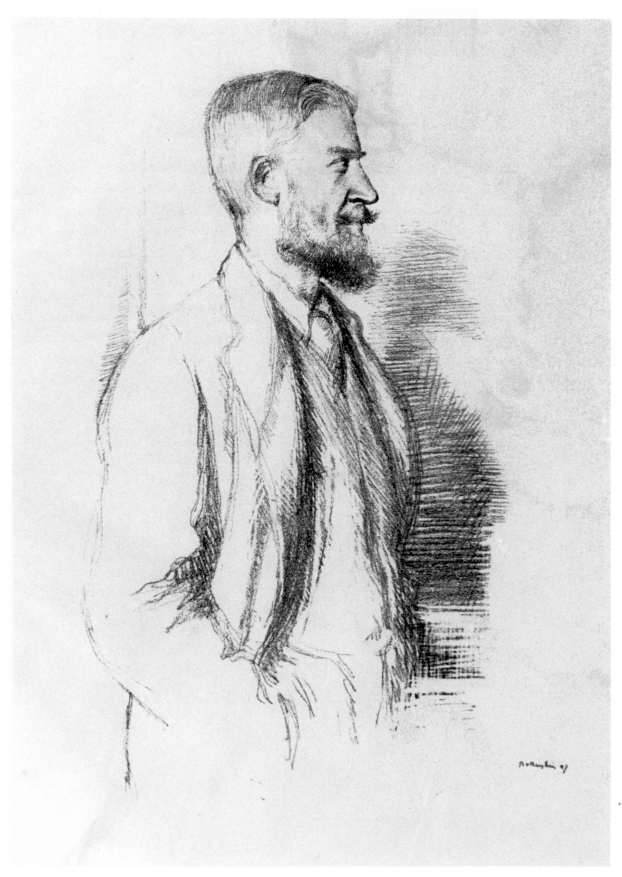

Rothenstein 97

107

Walter Sickert (1860-1942)

ARTIST AND JOURNALIST

Self-Portrait
ink and wash on buff paper, [1897]

Like Ida Nettleship and Augustus John, Walter Sickert began his art training as a pupil at London's Slade School. Like Nettleship, too, he later fell under the spell of J. M. Whistler—serving, for a time, as the American artist's assistant—and tried to apply Whistlerian principles and techniques throughout the early years of his career as a painter and etcher, especially in his portraits of contemporaries such as the Irish novelist, George Moore. During his lifetime, he created a number of self-portraits of which this drawing is possibly the least psychologically revealing, for it shows him only in profile, his expression unreadable. The year 1897, in which he produced this opaque image, was among the most difficult of his life. In his role as a writer on art, he had published a controversial piece for Frank Harris's *Saturday Review* asserting that Joseph Pennell's working methods as a printmaker were not those of a true lithographer. Pennell sued him for libel. Whistler, who was famously litigious, testified against his former assistant—a betrayal that ended the friendship between Sickert and his idol.

Sickert inv. et del.

Algernon Charles Swinburne (1837-1909)
POET AND CRITIC

pencil, 1860
by Dante Gabriel Rossetti (1828-1882)

Rossetti chose to idealize his friend, A. C. Swinburne, as a kind of medieval Knight of the Holy Pen, with a solemn, yet spiritual expression, a nimbus of waving hair, and eyes seemingly focused on a world beyond this one. But as Rossetti and his other intimates well knew, the young poet was far more interested in the pleasures afforded by the London nights than in the quests of any Arthurian knights. Given to long bouts of drunkenness that sometimes culminated in naked antics, Swinburne would run up against late Victorian censorship by hymning the praise of lost pagan days of color and sensuality associated with the Greeks and by expressing his distaste for the pallid, ascetic Christian era in which he was forced to abide.

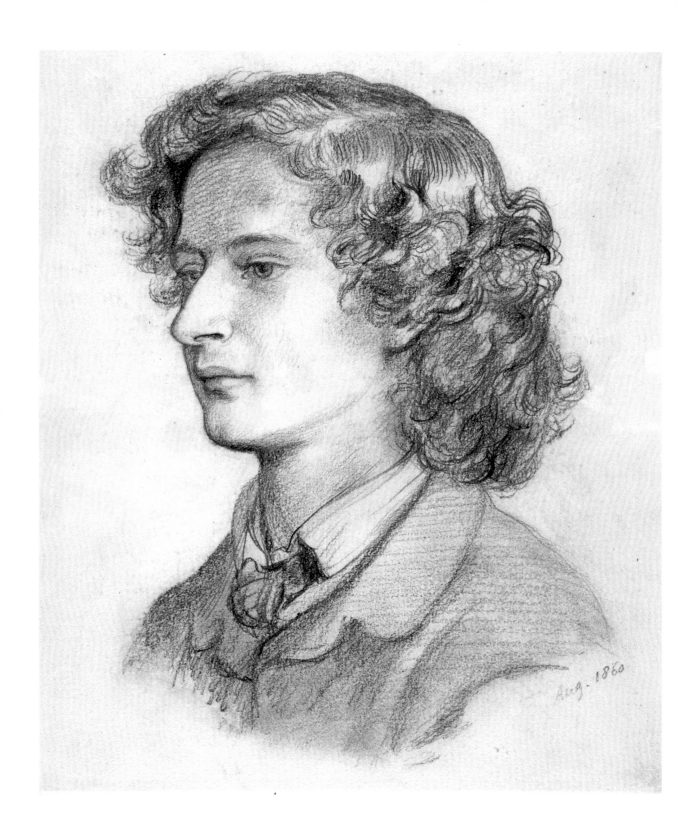

Algernon Charles Swinburne (1837-1909)

Mr. Swinburne
ink and wash, 1899
by Sir Max Beerbohm (1872-1956)

If Rossetti's portrait of A. C. Swinburne depicted him as a serious young visionary, Beerbohm's caricature of the older Swinburne showed him as a delightful kook. Picking up somewhat cruelly on Swinburne's disproportionately large skull and wispy body, Beerbohm turned the distinguished writer into a kind of late Victorian equivalent of a bobblehead doll. His drawing emphasized the restless energy of his subject, whose hands appeared to flutter and whose carpet-slippered feet seemed almost ready to dance off the page. Beerbohm, who was a critic-in-training himself, greatly admired Swinburne's acumen as a literary scholar and reviewer. Yet the artist would have felt that he was betraying his duty as a caricaturist, had he failed to make risible the eccentricities of his hero, who was by this time living a retired life in Putney under the watchful care of Theodore Watts-Dunton at "No. 2. The Pines" (the address that would later serve as the title of Beerbohm's essay about his visit there).

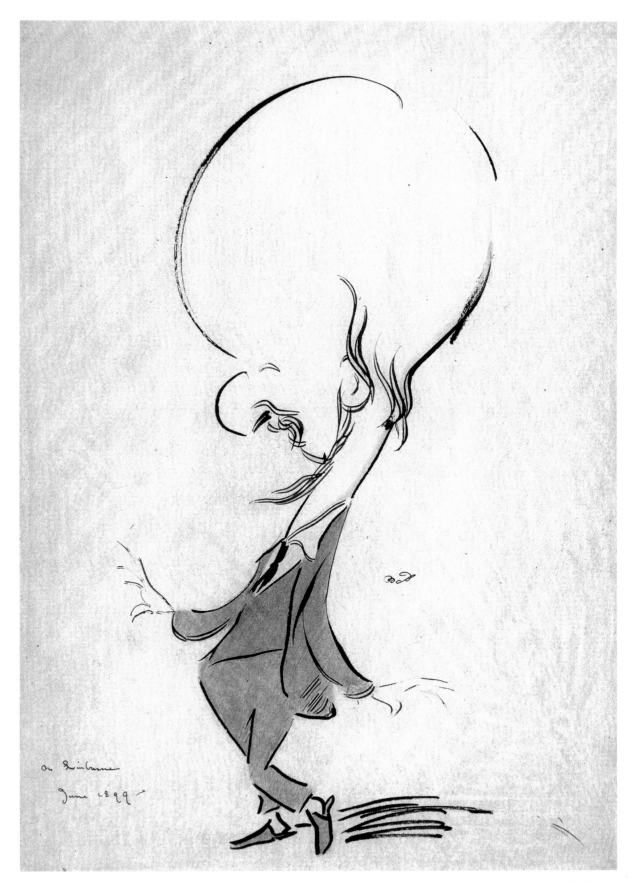

Mr Swinburne
June 1899

Alfred, Lord Tennyson (1809-1892)

POET LAUREATE

oil on panel, [ca. 1865-1870]
by Charles Lucy (1814-1873)

Alfred Tennyson (The Dirty Monk)
photograph, albumen, [1865]
by Julia Margaret Cameron (1815–1879)

In the 1860s, Julia Margaret Cameron began photographing the mournful, careworn face of Tennyson, her dear friend and neighbor on the Isle of Wight. This painting by Charles Lucy, a small study for a larger work meant for public display, dates from the same decade, and it is interesting to see in it the network of artistic cross-connections. Lucy's technique certainly shows the impress of the camera in its attempt to achieve a kind of verisimilitude associated with photography. Julia Margaret Cameron's images of Tennyson, on the other hand, were shaped just as much by a Victorian painterly aesthetic—in particular, by the attention to detail associated with Pre-Raphaelitism. But both painting and photography of the mid-to-late-nineteenth century were, in turn, influenced by an earlier tradition of portraiture, especially by the works of Velázquez and Van Dyck, who taught the Victorians that a representation of a great man should, on the one hand, offer an insight into the subject's soul, yet should also emphasize the sitter's worldly prestige and power.

115

Dame Ellen Terry (1847-1928)

ACTRESS AND WRITER

Ellen Terry as Olivia
pencil, 1878
by Violet Manners (née Lindsay), Duchess of Rutland (1856-1937)

In the Victorian period, there were few professional portrait photographers who were women; similarly, there were few female professional portrait painters. In place of women earning their livings in the field of portraiture, there were many instead who pursued it as a so-called hobby—well-to-do women who were also gifted artists. Julia Margaret Cameron stands as perhaps the greatest example of this phenomenon, for she advanced the art of capturing faces thanks to the happy accident of receiving a camera as a present. Far less remembered by history than Cameron was Violet Lindsay, who was both a titled aristocrat and a serious student of painting and drawing. In 1878, Lindsay produced this accomplished image of the actress Ellen Terry. (As a young woman, and as a very young wife to the painter G. F. Watts, Terry had by coincidence also sat for Julia Margaret Cameron.) It shows Terry in the role that was her first big success on the stage, as star of a sentimental comedy written for her by W. G. Wills and based on Goldsmith's *The Vicar of Wakefield*.

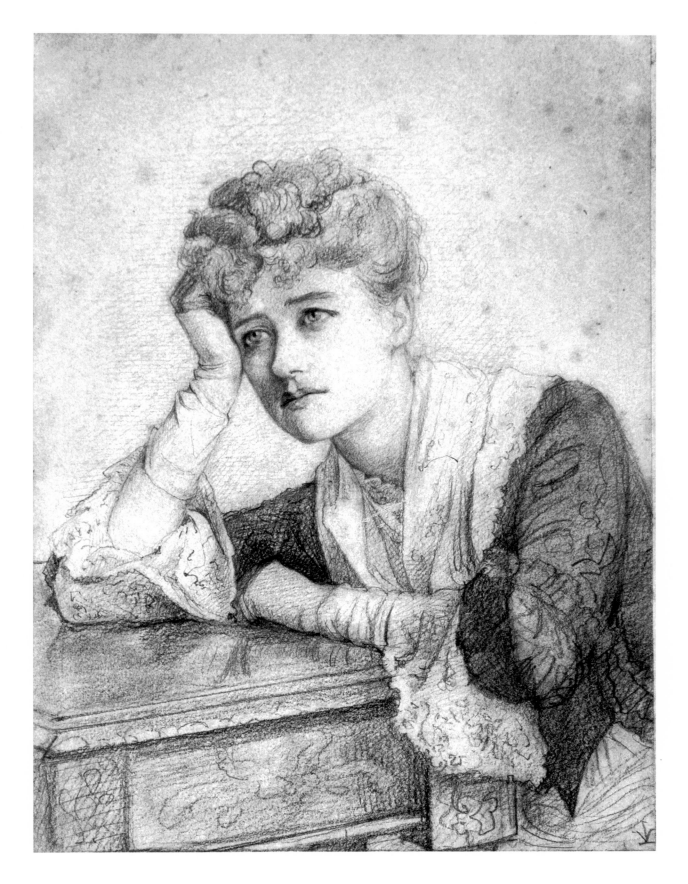

Victoria, Queen of Great Britain (1819-1901)

AUTHOR

> frontispiece in Queen Victoria, *More Leaves from the Journal of a Life in the Highlands, from 1862 to 1882* (London, 1884)
> engraving, "improved" in pencil and watercolor
> by Sir Max Beerbohm (1872-1956)

After the death of Prince Albert and the beginning of her long period of mourning, Victoria withdrew from public view. But she did not wholly vanish from public life, for she reappeared as an author through her published accounts of the world around Balmoral, her Scottish retreat and the backdrop for her great friendship with John Brown. As a late Victorian, who never saw the Queen in her vibrant youth and who grew up only with a vision of her as a dowdy old lady in black, Max Beerbohm felt singularly little reverence towards Victoria either as a monarch or as a writer. He was given in general to "improving" the images in the volumes that he owned, drawing quite vicious caricatures over the photographs in them, while also doctoring the text (as he has done in this case) with extracts from imaginary reviews or fake presentation inscriptions. His comic assault upon *More Leaves from the Journal of a Life in the Highlands* was particularly malicious, a gleeful puncturing of everything he judged solemn or pretentious. Beerbohm's "improvements" combined the high wit of social satire with the low humor favored by little boys who add naughty doodles to the pictures in a book.

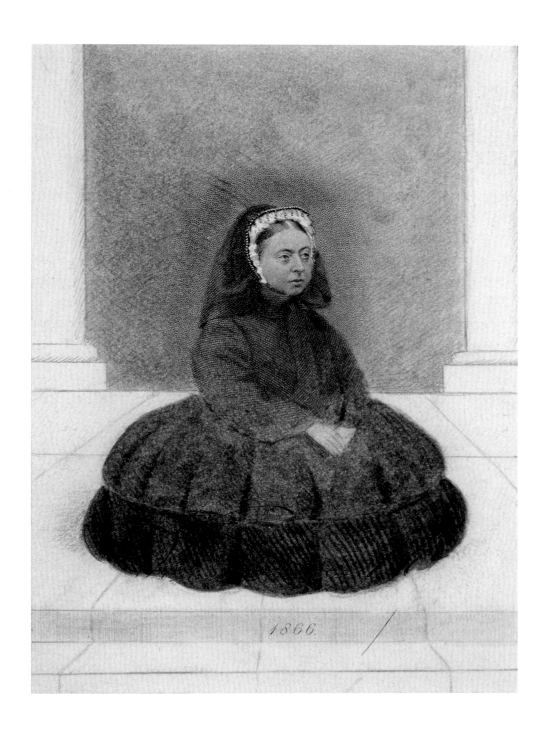

1866.

H. G. [Herbert George] Wells (1866-1946)

NOVELIST AND SHORT STORY WRITER

pencil and black crayon, [ca. 1900]
by Edmund J. Sullivan (1869-1933)

As the man who was said to have invented the future, H. G. Wells rapidly became the object of a cult–following after the publication in the 1890s of his great "scientific romances," including *The Time Machine*, *The Island of Dr. Moreau*, and *The Invisible Man*. But his appearance was not that of the popular stereotype of a godlike visionary or prophet. As he was all too aware, he looked like what he was—the son of a domestic servant and of a shopkeeper, who showed the effects of the bad diet and poor health to which people of his class were subject while growing up. He could have passed for one of the heroes of his later serio-comic novels, a draper's assistant. A talented amateur artist, he enjoyed illustrating letters to friends or lovers with self-caricatures and invariably portrayed himself as an insignificant figure with a brushy moustache, when not as some form of comical animal.

James McNeill Whistler (1834-1903)

ARTIST

ink, 1890
by Sydney Starr (1857-1925) and James McNeill Whistler (1834-1903)

Whistler was in love with a particular image of female beauty—slender, elongated, aesthetically robed, and japonesque. But it is fair to say that he was equally in love with his own image, which was just as artificial and self-conscious a creation. In assembling it, he blended a variety of existing elements that signified different types of Victorian masculinity. From the dandy, he borrowed the monocle and careful coiffeur (it was said that every morning he colored his hair to achieve its distinctive single lock of white); from the bohemian the long coat and the wide-brimmed hat; and from the gentleman the stick and waxed moustache. It was a visual statement designed to attract attention, and it succeeded. Whistler became the subject of countless portraits and caricatures— and, of course, of self-portraits in oil that were inspired by Rembrandt—throughout the final decades of the nineteenth century. This drawing, originally intended for reproduction in a periodical called the *Whirlwind* (which had a fittingly short life and then blew away), bears the stamp of two hands. It was begun by one of Whistler's protégés, Sydney Starr, but completed by the "Master" himself and hence displays his famous butterfly signature.

1890.

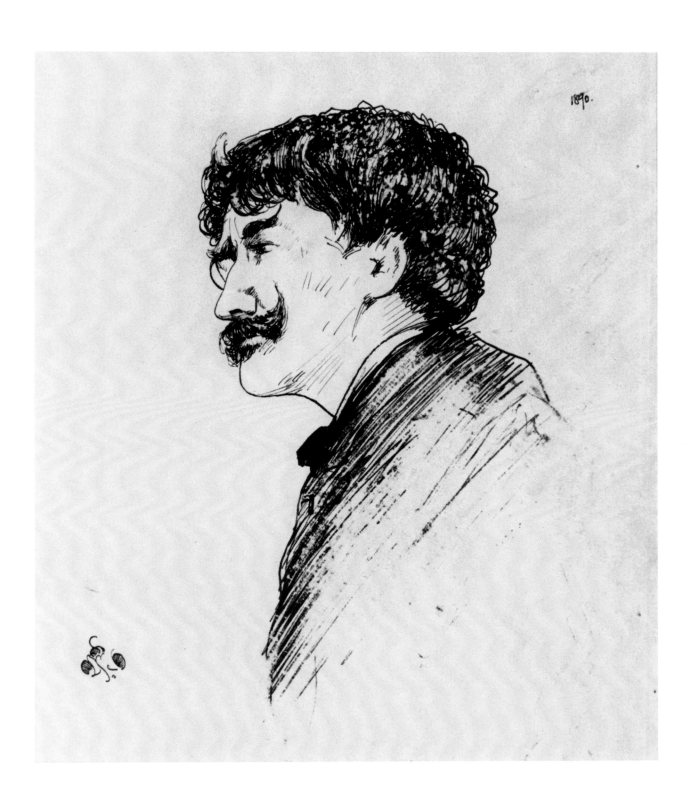

James McNeill Whistler (1834-1903)

woodcut, heightened with watercolor, [1897]
by Sir William Nicholson (1872-1949)

Influenced by the aesthetic that he absorbed from the Japanese woodblock prints circulating throughout the late Victorian art world, William Nicholson aimed for economy of line, asymmetry in composition, and boldness of effect. His portrait of Queen Victoria as an almost faceless mass of blackness, looking more like Edgar Allan Poe's sinister raven than like the stately Empress of India, was considered a shocking one by readers of the *New Review*. (W. E. Henley, the magazine's editor, had commissioned him to produce a series of celebrity images, a common feature of the New Journalism at century's end.) Nicholson's portrait of J. M. Whistler, too, in this rare hand-colored woodcut, managed to impose upon the viewer through suggestion, rather than through elaborate detail, the artist's vision of his subject's personality. In this case, Nicholson conveyed through the posture of the figure and the tilt of its head how Whistler confronted the world: defiantly, even somewhat belligerently, and with a matchless confidence in the correctness of his own opinions.

Oscar Wilde (1854-1900)

POET, CRITIC, NOVELIST, AND PLAYWRIGHT

Oscar
color lithograph, 1884
by Ape [Carlo Pellegrini] (1839-1889)
from *Vanity Fair* (24 May 1884)

A decade-and-a-half before his arrest and imprisonment rocked the world of the arts in Britain, Oscar Wilde was already understood to represent a challenge to conventional Victorian gender roles. In the early 1880s, even before he was known as a writer of anything but a single volume of poetry, he became an obsession among journalists and, especially, among caricaturists. Needless to say, he welcomed the attention, on the grounds that the only thing worse than being talked about was not being talked about. But there was perhaps even more drawing of his face and body than talking going on around him. After his first American tour of 1882, artists on both sides of the Atlantic demonstrated how disturbing—in some cases, how disturbingly attractive—they found his aesthetic costume and self-presentation. Among the mildest visual lampoons of Wilde from this period was *Oscar* by Ape (i.e., Carlo Pellegrini), one of the two caricaturists closely identified with the mainstream British weekly, *Vanity Fair* (the other was Leslie Ward, a.k.a. Spy).

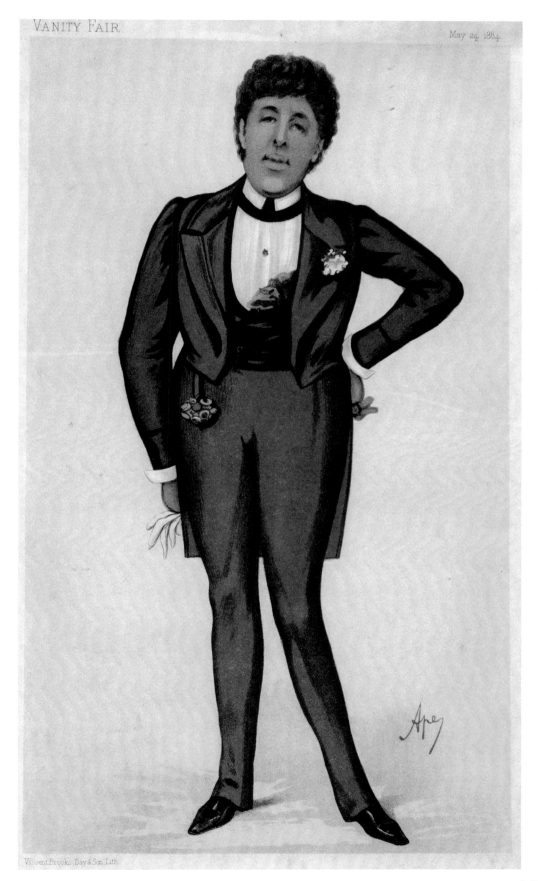

Vincent Brooks, Day & Son, Lith.

Oscar Wilde (1854-1900)

lithograph by C. R.
caricature, front cover of sheet music, *The Oscar Wilde Galop, Arr. Snow*
[J. Albert Snow?] [New York, ca. 1882]

Oscar Wilde came to America in 1882 to capitalize (quite literally) on Richard D'Oyly Carte's production there of *Patience*, the Gilbert and Sullivan operetta that contained a recognizable comic portrait of him as the aesthete named Bunthorne. But even as Wilde earned money by lecturing across the United States, others also profited off of him and especially off of his image. Numerous commercial interests recognized the value of affixing portraits of the new cultural sensation from abroad to their wares, with or without his consent. Some of these were dreadfully unflattering caricatures—especially of Wilde's carefully devised costume of velvet jacket, knee breeches, and stockings—that rendered his artistic self-presentation as mere effeminacy.

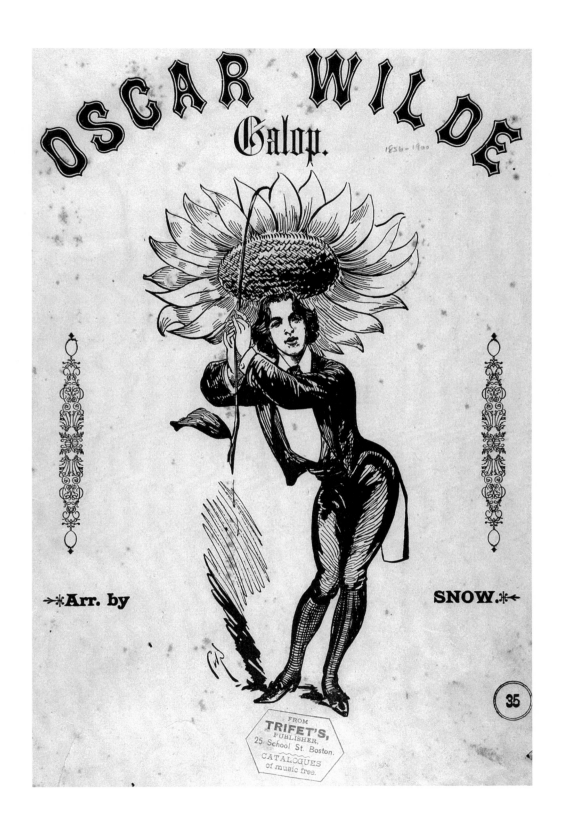

Oscar Wilde (1854-1900)

pencil, ink, and watercolor, [ca. 1894-1900]
by Sir Max Beerbohm (1872-1956)

"Yet each man kills the thing he loves," Oscar Wilde would write in his last great work, *The Ballad of Reading Gaol*. Whenever Max Beerbohm took up his pen to caricature Wilde, it was filled with poison, for Wilde was also a beloved idol from whose influence Beerbohm could only free himself through lethal satire. This particular image—surely one of the most uncomplimentary ever done of Wilde—was not meant for public consumption. Beerbohm gave it to Reginald Turner, who shared his devotion to Wilde's writing and also his occasional need to "kill" Wilde to avoid being overwhelmed. Beerbohm's way of distancing himself from Wilde was by exaggerating the latter's Dionysian, hedonistic side, while presenting himself (especially in self-caricatures) as a more restrained and Apollonian version of the aesthete. But some of Beerbohm's attitude toward Wilde's self-indulgence might be attributed to the disapproval that youth often registers at the sight of its elders enjoying themselves. In the case of Beerbohm, who was eighteen years Wilde's junior, we might call this an example of the young regarding with horror—to paraphrase *The Importance of Being Earnest*—such reckless extravagance in one so middle-aged.

W. B. [William Butler] Yeats (1865-1939)

POET AND PLAYWRIGHT

lithograph, [1898]
by Sir William Rothenstein (1872-1945)
from William Rothenstien, *Liber Juniorum: Six Lithographed Drawings*
(London, 1899)

Like Richard Le Gallienne, W. B. Yeats learned much from the high standard of public self-presentation set by Oscar Wilde in the 1880s. While working diligently to make himself the creative center of the Celtic Renaissance, Yeats also knew that he needed to fashion a persona and an appearance to match. As befitted someone who wished to earn a dual reputation—as a scholar of Irish legends and language, as well as a poet-dramatist—he chose a look that was studious (hence the pince-nez spectacles, which he was so often photographed wearing), yet romantic, with flopping hair and floppy ties. Nature had, moreover, given him the advantage of a high forehead. Those who drew him and emphasized this feature were as aware as Yeats himself that, according to the rules of late Victorian physiognomy, a lofty brow supposedly signaled lofty thoughts.

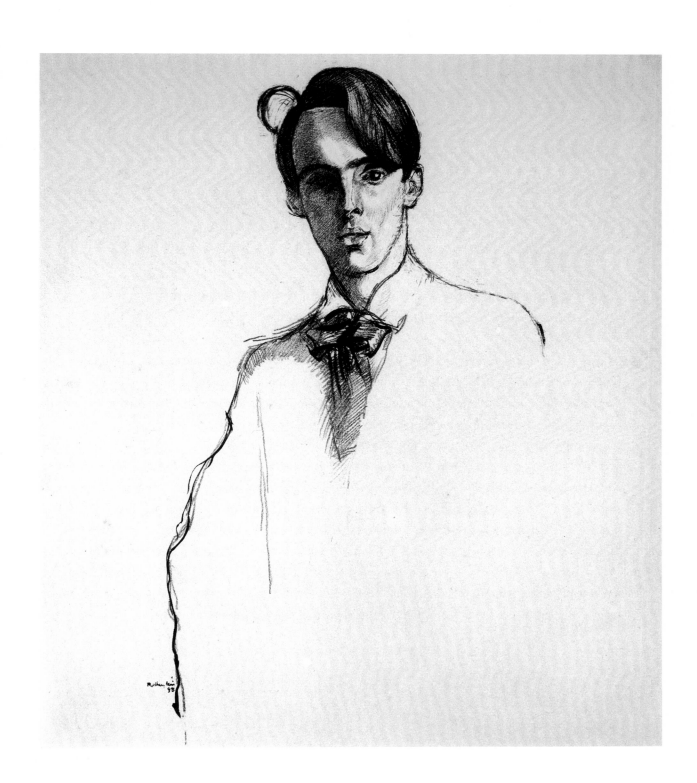

133

Living English Poets

Robert Browning (1812-1889)
POET

Matthew Arnold (1822-1888)
William Morris (1834-1896)
Algernon Charles Swinburne (1837-1909)
Alfred, Lord Tennyson (1809-1892)

caricature by Walter Crane (1845-1915), reproduced as frontispiece to
Living English Poets MDCCCLXXXII (London, 1883)

The most appealing portraits done of William Morris in his lifetime were surely the caricatures of him by the painter Edward Burne-Jones. In those sketches meant to circulate only among close friends, Burne-Jones depicted the multi-talented artist and writer as squat, square-bodied, bushy-haired, and always busily in motion, like a hyper-kinetic woodchuck. Walter Crane was also a friend, as well as a fellow traveller in socialist circles. Yet his version of William Morris was far less kindly. In the frontispiece for *Living English Poets*, Matthew Arnold, Robert Browning, Algernon Charles Swinburne, and Alfred, Lord Tennyson, are all mildly satirized, as they cluster around a muse of poetry who looks rather like a George Du Maurier maiden missing some of her clothes. The portrait of William Morris, however, as a loafing, daisy-picking dreamer is not only a harsh lampoon, but an oddly inappropriate one, for no one was ever less of an idler than the multi-tasking writer, artist, and designer in the decorative arts. This copy of the book belonged to Christina Rossetti, several of whose poems appeared in the anthology. Along with the other women represented in the volume, she seems to have been saved from caricature by Walter Crane's adherence to gendered notions of propriety.

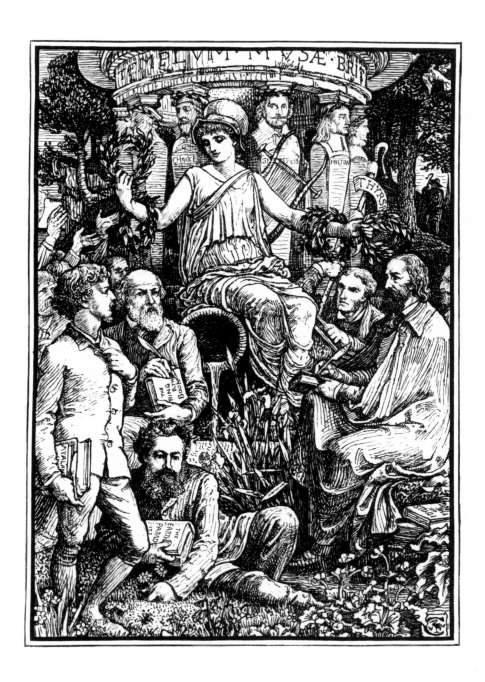

Cope's Christmas Card, December 1883

watercolor, 1883
by George Pipeshanks [John Wallace] (fl. 1880-1895)

Group portraits featuring recognizable public figures were a staple of nineteenth-century high art. Some of these paintings were meant to commemorate turning-points in politics, such as a major speech delivered in Parliament; others, more self-referentially, recorded important moments in the world of the arts. Into this latter category fell paintings such as Charles West Cope's *The Council of the Royal Academy Selecting Pictures for the Exhibition* (1876) and William Powell Frith's *Private View of the Royal Academy* (1881), the latter featuring images of Oscar Wilde, Ellen Terry, and George Du Maurier, among other late Victorian notables. Not surprisingly, caricaturists produced their own satirical versions of the genre, resulting in works such as Walter Crane's frontispiece for *Living English Poets* and later, Max Beerbohm's *Will Rothenstein Laying Down the Law*, which allowed the comic artist to skewer a number of contemporaries at once, arranging them like so many pieces of shish kebab. But the large-group portrait could also serve the ends of commercial artists. Advertisers who wished to associate their products with celebrities rarely bothered to pay for endorsements; instead, without seeking permission, they commissioned illustrators to draw images of the great and famous—the more of them, the better. When, for instance, Cope's tobacco company wished to suggest that prominent figures from J. M. Whistler and Oscar Wilde to Robert Browning and Matthew Arnold were fans of its wares, it employed John Wallace (a.k.a. George Pipeshanks) to depict them all and reproduced his panoramic watercolor on a card, which was sent free upon request to its customers at Christmastime. The card was accompanied by a numbered key, which encouraged viewers to increase what we might call their celebrity literacy, as they learned to identify the caricatured features of people, including writers and artists, whom they might not otherwise have named immediately. Famous faces became public property. But at the end of the nineteenth century and then throughout the twentieth and early twenty-first centuries, they also turned into commercial property. Spectators consumed portraits, and portraits sold consumer goods. The image of the human face served as the visible and irreplaceable point of intersection where high art, popular art, publishing, technology, business, and entertainment all might meet and indeed still do meet today.

[See frontispiece illustration]

PROVENANCE, EXHIBITIONS, AND LITERATURE *Compiled by Mark Samuels Lasner*

❧ LIST OF SHORT TITLES

Bilski and Braun

Emily Bilski and Emily Braun, *Jewish Women and Their Salons: The Power of Conversation* (New York, 2005)

Cadden and Jensen

Michael Cadden and Mary Ann Jensen, *Oscar Wilde: A Writer for the Nineties* (Princeton, NJ, 1995)

Cambridge, MA 1994

The Yellow Book: A Centenary Exhibition, Houghton Library, Harvard University, Cambridge, MA, 1 March–8 April 1994

Cecil

David Cecil, *Max: A Biography* (London, 1964)

Charlottesville, VA 1985

The English Avant-Garde of the 1880s, University of Virginia Library, Charlottesville, VA, 2 February–31 March 1985

Davies

Adriana Davies, comp., *Dictionary of British Portraiture, Vol. 4, The Twentieth Century, Historical Figures Born Before 1900*, ed. Richard Ormond and Malcolm Rogers (London, 1981)

Delaney

Paul Delaney, *The Lithographs of Charles Shannon: A Catalogue* (London, 1978)

Frederick

Margaretta Frederick, *Charles Shannon: Lithographs and Luminaries* (Wilmington, DE, 2006)

Hall, *Max Beerbohm*

N. John Hall, *Max Beerbohm: A Kind of a Life* (New Haven, CT, 2002)

Hall, *Max Beerbohm Caricatures*

N. John Hall, *Max Beerbohm Caricatures* (New Haven, CT, 1997)

Hart-Davis

Rupert Hart-Davis, *A Catalogue of the Caricatures of Max Beerbohm* (London, 1972)

Kilmurray

Elaine Kilmurray, comp., *Dictionary of British Portraiture, Vol. 3, The Victorians, Historical Figures Born Between 1800 and 1860*, ed. Richard Ormond and Malcolm Rogers (London, 1981)

New York 1992

The English 'Nineties: A Selection from the Library of Mark Samuels Lasner, Grolier Club, New York, 22 January–20 March 1992

New York 1996-1997

William Morris: The Collector as Creator, Grolier Club, New York, 11 December 1996–15 February 1997

New York 2001-2002

Oscar Wilde: A Life in Six Acts, Morgan Library, New York, 14 September 2001–13 January 2002

New York and Chestnut Hill, MA 2005

The Power of Conversation: Jewish Women and their Salons, Jewish Museum, New York; McMullen Museum, Boston College, Chestnut Hill, MA, 2005

Newark, DE 2002

Beyond Oscar Wilde: Portraits of Late-Victorian Writers and Artists from the Mark Samuels Lasner Collection, University Gallery, University of Delaware, Newark, DE, 5 September–10 November 2002

Princeton, NJ 1995

Oscar Wilde: A Writer for the Nineties, Princeton University Library, Princeton, NJ, 30 April–1 September 1995

Ricketts

Charles Ricketts, *A Catalogue of Mr. Shannon's Lithographs* (London, 1902)

Rothenstein, *Men and Memories*

William Rothenstein, *Men and Memories: Recollections of William Rothenstein, 1872–1900* (London, 1931)

Rothenstein, *Portrait Drawings*

John Rothenstein, *The Portrait Drawings of William Rothenstein, 1889–1925: An Iconography* (London, 1926)

Samuels Lasner, *English 'Nineties*

Mark Samuels Lasner, *The English 'Nineties: A Selection from the Library of Mark Samuels Lasner* (New York, 1992)

Samuels Lasner, *William Morris*

Mark Samuels Lasner, *William Morris: The Collector as Creator* (New York, 1996)

Speaight

Robert Speaight, *William Rothenstein: The Portrait of an Artist in his Time* (London, 1972)

Stetz and Samuels Lasner, *England in the 1880s*

Margaret D. Stetz and Mark Samuels Lasner, *England in the 1880s: Old Guard and Avant-Garde* (Charlottesville, VA, 1989)

Stetz and Samuels Lasner, *England in the 1890s*

Margaret D. Stetz and Mark Samuels Lasner, *England in the 1890s: Literary Publishing at the Bodley Head* (Washington, DC, 1990)

Stetz and Samuels Lasner, *Yellow Book*

Margaret D. Stetz and Mark Samuels Lasner, *The Yellow Book: A Centenary Exhibition* (Cambridge, MA, 1994)

Washington, DC 1989-1990

England in the 1890s: Literary Publishing at the Bodley Head, Georgetown University Library, Washington, DC, 15 December 1989–9 March 1990

Wilmington, DE 2006

Charles Shannon: Lithographs and Luminaries, Delaware Art Museum, Wilmington, DE, 17 March–9 July 2006

William Allingham (1824-1889)
watercolor, [ca. 1880]
by Helen Allingham (1848-1926)
16.8 × 13.6 cm. (6.625 × 5.375 in.)
signed with monogram upper left
PROVENANCE: Christopher Wood Gallery, London;
Kelmscott Gallery, Chicago. Acquired: March 1982 from
Bromer Booksellers, Boston
EXHIBITED: *Helen Allingham: The Victorian Garden*,
Christopher Wood Gallery, London, May–June 1980;
From Blake to Beardsley, Kelmscott Gallery, Chicago,
November 1981–January 1982, no. 1; *Meeting the Brown-
ings*, Armstrong Browning Library, Baylor University,
Waco, TX, 15 April–17 May 1986; Newark, DE 2002
LITERATURE: H, Allingham and D. Radford, ed.,
William Allingham: A Diary (London, 1907), repro. pl.
facing 307; Mark Samuels Lasner, *William Allingham: A
Bibliographical Study* (Philadelphia, 1993), 70, repro.
frontispiece

William Archer (1856-1924)
Mr. William Archer
pencil, ink, pastel and watercolor, [1896]
by Sir Max Beerbohm (1872-1956)
37.1 × 22.2 cm. (14.625 × 8.75 in.)
signed "Max" upper right and inscribed with title
PROVENANCE: Illustrated and Private Press Books,
Children's Books and Juvenilia, The Performing Arts,
Related Drawings, Sotheby's, London, 6 December
1990, no. 338. Acquired: July 1993 from Piccadilly
Gallery, London
EXHIBITED: Princeton, NJ 1995, no. 20; Newark, DE
2002; *Gender and the London Theatre, 1880–1920*, Bryn
Mawr College Library, Bryn Mawr, PA, 28
September–19 December 2003
LITERATURE: Cadden and Jensen, 16, no. 20; *Chap-
Book* [Chicago], 1 October 1896, repro. pl. facing viii;
Echo [Chicago], Extra issue, November-December 1896,
repro. 249; Hall, *Max Beerbohm Caricatures*, 82, repro.
pl. 67; Hart-Davis, 22, no. 22; Roy Huss, "Max
Beerbohm's Drawings of Theatrical Figures (III),"
Theatre Notebook (Summer 1967): 169; Wendy Wick
Reaves, *Celebrity Caricature in America* (New Haven,
CT, 1998), 38, repro. fig. 2.15; Margaret D. Stetz,
Gender and the London Theatre, 1880–1920 (High
Wycombe, Bucks., UK, 2004), 48, repro. 49

Matthew Arnold (1822-1888) and his wife, *Frances
Lucy Arnold* (née Wightman) (1825–1901)
photographs, albumen cartes-des-visites, [1880s]

by Elliott and Fry, London
9.3 × 5.7 cm. (3.675 × 2.25 in.) each
tipped in Matthew Arnold, *Poems* (London, 1895)
PROVENANCE: Lilian Darlington (book and photo-
graphs presented by Frances Arnold as a wedding pres-
ent, November 1897). Acquired: February 2000 from
Thomas Goldwasser Rare Books, San Francisco
EXHIBITED: Newark, DE 2002
LITERATURE: *The Letters of Matthew Arnold, Vol. 5,
1879–1884*, ed. Cecil Y. Lang (Charlottesville, VA, 2001),
repro. xxiv–xxv; Heather Henderson and William Sharpe,
*The Longman Anthology of British Literature, Third Edi-
tion, Volume 2B, The Victorian Age*, ed. David Damrosch
and Kevin J. H. Dettmar (New York, 2005), repro. 1567:
Kilmurray, 8, for photograph of Matthew Arnold

Sir J. M. [James Matthew] Barrie (1860-1937) and
Mary De Navarro (née Anderson) (1859-1940)
caricature, *Result of the Match, 1898*, by Sir Bernard
Partridge (1861-1945), reproduced in *The Allahakbarrie
Book of Broadway Cricket for 1899* [London, 1899]
PROVENANCE: Faith, Lady Partridge (wife of Sir
Bernard Partridge). Acquired: Fine Books and
Manuscripts, Sotheby's, New York, 14 February 1986,
no. 68. via David J. Holmes Autographs, Hamilton, NY
EXHIBITED: Newark, DE 2002
LITERATURE: J. M. Barrie, *J. M. Barrie's Allahakbarries
C. C., 1899*, foreword by Don Bradman (ondon,
1950); R. D. Cutler, *Sir James Barrie: A Bibliography*
(New York, 1931), 127, no. 50; Herbert Garland, *A
Bibliography of the Writings of Sir James Matthew
Barrie* (London, 1928), 62–63, no. 27; E. W. Padwick,
comp., *A Bibliography of Cricket* (London, 1977), 82, no.
1296; Alfred D. Taylor, *The Catalogue of Cricket
Literature* (London, 1972), 28; Timothy G. Young, *My
Heart in Company: The Work of J. M. Barrie and the
Birth of Peter Pan* (New Haven, CT, 2005), 35, repro. 34

Aubrey Beardsley (1872-1898)
lithograph (proof), 1897
by Sir William Rothenstein (1872-1945)
42.5 × 27.9 cm. (16.75 × 11 in.)
inscribed "To my good friend Aubrey Beardsley —Will
Rothenstein June 97" lower right
PROVENANCE: Aubrey Beardsley (presented by
Rothenstein, June 1897); the sitter's mother, Ellen Pitt
Beardsley; Sir Hugh Walpole; Leicester Galleries,
London; Derek Hudson; Alexander D. Wainwright.
Acquired: February 2000 from Joseph J. Felcone Inc.,
Princeton, NJ

EXHIBITED: *Loan Exhibition of Drawings by Aubrey Beardsley, 1872–1898*, National Gallery, Millbank, London, 1 November 1923–1 March 1924, no. 4; *Exhibition of the Collection of the Late Sir Hugh Walpole, Part 3*, Leicester Galleries, London, June 1945, no. 60; *Aubrey Beardsley*, Victoria and Albert Museum, London, 20 May–18 September 1966, no. 610; *Aubrey Beardsley*, Gallery of Modern Art, New York, 4 February–9 April 1967, no. 507; *Aubrey Beardsley, 1872–98: A Centennial Exhibition*, Princeton University Library, Princeton, NJ, 5 October 1998–8 April 1999; Newark, DE 2002

LITERATURE: National Gallery, Millbank, *Catalogue: Loan Exhibition of Drawings by Aubrey Beardsley, 1872–1898* (London, 1923), 6, no. 4; *The Letters of Aubrey Beardsley*, ed. Henry Maas, J. L. Duncan, and W. G. Good (Rutherford, NJ, 1970), 320, 331; Davies, 8; Brian Reade and Frank Dickinson, *Aubrey Beardsley: Exhibition at the Victoria and Albert Museum, 1966: Catalogue of the Original Drawings, Letters, Manuscripts, Paintings, and of Books, Posters, Autographs, Documents, etc.* (London, 1966), no. 610; "Recent Paintings by Mr. Duncan Grant," *The Times*, 3 July 1945, 6; Rothenstein, *Portrait Drawings*, 98, no. 75; Rothenstein, *Men and Memories*, 317–18, 323, repro. pl. facing 307; Stanley Weintraub, *Aubrey Beardsley: Imp of the Perverse* (University Park, PA, 1976), 234

Aubrey Beardsley (1872-1898)

photograph, silver gelatin, [1897]
by Abel, Menton
21.6 × 28.2 cm. (8.5 × 11.125 in.)
inscribed on mount "To H.C. J. Pollitt from Aubrey Beardsley"

PROVENANCE: Herbert Pollitt (inscribed by Beardsley); Phil Burns. Acquired: Aubrey Beardsley, Sotheby's, London, 18 November 1998, no. 123, via Bertram Rota, London

EXHIBITED: Newark, DE 2002

LITERATURE: *The Letters of Aubrey Beardsley*. ed. Henry Maas, J. L. Duncan, and W. G. Good (Rutherford, NJ, 1970), 400; Aubrey Beardsley, *Under the Hill and Other Essays in Prose and Verse* (London, 1904), repro. frontispiece; Stephen Calloway, "The Last Portrait of Aubrey Beardsley," in Steven Halliwell and Matthew Sturgis, ed., *The Death of Pierrot: A Beardsley Miscellany* (Arncott, Oxfordshire, 1998), 71–74; Brian Reade and Frank Dickinson, *Aubrey Beardsley: Exhibition at the Victoria and Albert Museum, 1966: Catalogue of the Original Drawings, Letters, Manuscripts, Paintings, and of Books, Posters, Photographs, Documents, etc.* (London, 1966), nos. 607, 610; Matthew Sturgis, *Aubrey Beardsley: A Biography* (London, 1998), 346; Gail

S. Weinberg, "Aubrey Beardsley, The Last Pre-Raphaelite," in Susan P. Casteras and Alicia Craig Faxon, ed., *Pre-Raphaelite Art in its European Context* (Madison, NJ, 1995), 230, repro. fig. 11; Stanley Weintraub, *Aubrey Beardsley: Imp of the Perverse* (University Park, PA, 1976), 250; Linda Zatlin, "Drawing Conclusions: Beardsley and Biography," *Biography: An Interdisciplinary Quarterly* 15 (1992): 123, 128–29

Sir Max Beerbohm (1872-1956) with Sir William Rothenstein (1872-1945)

photograph, albumen cabinet card, [1893]
by Gillman and Company, Oxford
13.3 × 10.3 cm. (5.25 × 4.0625 in.)
signed by the sitters, "Max Beerbohm" and "William Rothenstein," at top

PROVENANCE: Max Beerbohm; Elizabeth, Lady Beerbohm (née Jungmann); Sir Rupert Hart-Davis. Acquired: October 1993 from Bertram Rota, London

EXHIBITED: Cambridge, MA 1994, no. 13; New York 2001-2002; Newark, DE 2002; New York and Chestnut Hill, MA 2005

LITERATURE: Cecil, repro. 94; Hall, *Max Beerbohm*, repro. pl. 3; Hall, *Max Beerbohm Caricatures*, repro. fig. ii; *Max and Will: Max Beerbohm and William Rothenstein, Their Friendship and Letters, 1893 to 1945*, ed. Mary M. Lago and Karl Beckson (London, 1975), repro. pl. facing 42; Stetz and Samuels Lasner, *Yellow Book*, 59, no. 14

Sir Max Beerbohm (1872-1956)

Self-Caricature
pencil, ink, and watercolor, [ca. 1900]
41.3 × 30.5 cm. (16.25 × 12 in.)
signed "Max" upper right

PROVENANCE: possibly from the collection of Martin Birnbaum. Acquired: March 1993 from The Book Block, Greenwich, CT

EXHIBITED: Newark, DE 2002; New York and Chestnut Hill, MA 2005

LITERATURE: Bilski and Braun, repro. 53; Hall, *Max Beerbohm Caricatures*, 221, repro. pl. 210; Wendy Wick Reaves, *Celebrity Caricature in America* (New Haven, CT, 1998), repro. fig. 2.4

Sir Max Beerbohm (1872-1956)

pencil and ink, [ca. 1898-1899]
by Sir William Rothenstein (1872-1945)
27 × 19 cm. (10.625 × 7.5 in.)
signed with initials and dated indistinctly lower left

PROVENANCE: Rothenstein family. Acquired: August 1990 from Warrack and Perkins, Church Enstone, Oxfordshire

EXHIBITED: New York 1992; Newark, DE 2002

LITERATURE: Samuels Lasner, *English 'Nineties*, 12

Wilfrid Scawen Blunt (1840-1922)

photograph, albumen, [ca. 1882]

9.5 × 5.4 cm. (3.75 × 2.125 in.)

tipped in Wilfrid Scawen Blunt, *Esther, Love Lyrics, and Natalia's Resurrection* (London, 1892)

PROVENANCE: Lady Gregory (book presented by Blunt, May 1893). Acquired: June 1986 from Holleyman and Treacher, Brighton, Sussex

EXHIBITED: Newark, DE 2002

Sir Edward Burne-Jones (1833-1898)

Burne-Jones Painting

pencil, [ca. 1884-95]

by George James Howard, Ninth Earl of Carlisle (1843-1911)

34.3 × 24.4 cm. (13.5 × 9.625 in.)

PROVENANCE: Ian Hodgkins and Co., London; Fine Art Society, London. Acquired: Early English Drawings and Watercolours and Victorian Watercolours, Sotheby's, London, 24 September 1987, no. 526, via Bertram Rota, London

EXHIBITED: *English 19th Century Pre-Raphaelite and Academic Drawings, Watercolors, Graphics, and Paintings*, Shepherd Gallery, New York, 12 March–26 April 1986, no. 43; New York 1996-1997, no. 71; Newark, DE 2002

LITERATURE: Charlotte Gere and Geoffrey C. Mason, *Artists' Jewellery: Pre-Raphaelite to Arts and Crafts* (Woodbridge, Suffolk, UK, 1989), repro. pl. 83; Samuels Lasner, *William Morris*, 18, no. 71; Christopher Wood, *Burne-Jones: The Life and Works of Sir Edward Burne-Jones (1833–1898)* (London, 1998), repro. 44

Sir Hall Caine (1854-1931)

Mr. Hall Caine

ink on blue paper, [1898]

by Sir Max Beerbohm (1872-1956)

32.4 × 20.1 cm. (12.75 × 7.9 in.)

signed "Max" upper right and inscribed with title

PROVENANCE: Agnes Beerbohm; Mrs. John Walker; Modern British and Irish Paintings, Drawings, and Sculpture, 13 June 1980, part of no. 42. Acquired: June 1981 from Piccadilly Gallery, London

EXHIBITED: *Max Beerbohm, 1872–1956: A Collection of Watercolours and Drawings*, Piccadilly Gallery, London, 7 October–1 November 1980, no. 43; *A Peep Into the Past: Max Beerbohm Caricatures*, Bertha and Karl Leubsdorf Art Gallery, Hunter College, New York; Delaware

Art Museum, Wilmington, DE, 1987; Newark, DE 2002

LITERATURE: Max Beerbohm, "Nat Goodwin—and Another," in *Mainly on the Air* (London, 1957), 67; S. N. Behrman, *Portrait of Max* (New York, 1960), 274; Lawrence Danson, *Max Beerbohm and the Act of Writing* (Oxford, 1989), 237, repro. pl. 26; Hart-Davis, 39, no. 216, for similar caricature; Hall, *Max Beerbohm Caricatures*, 34, repro. pl. 20; *A Peep Into the Past: Max Beerbohm Caricatures*, curated and with an essay by N. John Hall (New York, 1987), 50, repro. pl. 10

Ella D'Arcy (1856?-1937)

painting, *A Lady*, [ca. 1892–94], by Philip Wilson Steer (1860–1942), reproduced in the *Yellow Book* 2 (July 1894)

ACQUIRED: January 1975 from Brattle Book Shop, Boston

EXHIBITED: Newark, DE 2002

LITERATURE: Penelope Fitzgerald, *Charlotte Mew and Her Friends* (London, 1984), 82, repro. 65; Bruce Laughton, *Philip Wilson Steer, 1860–1942* (Oxford, 1971), 60, 133, no. 110, repro. pl. 101; Mark Samuels Lasner, *The Yellow Book: A Checklist and Index* (London, 1998). 23

George Du Maurier (1834-1896)

photograph, carbon, [ca. 1890s]

by Elliott and Fry, London

24.8 × 18.1 cm. (9.75 × 7.125 in.)

signed "George Du Maurier" on mount lower right, with identification inscription at center

EXHIBITED: Newark, DE 2002

LITERATURE: Kilmurray, 59

George Egerton [Mary Chavelita Dunne Bright] (1859-1945)

photograph, albumen cabinet card, [ca. 1894]

by J. Russell and Sons, London

14.6 × 10.3 cm. (5.75 × 4.0625 in.)

signed "George Egerton" and "Mrs. Clairmonte" on verso

PROVENANCE: J. M. Bulloch; Warrack and Perkins, Church Enstone, Oxfordshire. Acquired: November 1979 from Charles Cox, Cheriton Fitzpaine, Devon

EXHIBITED: Washington, DC 1989-1990, no. 53; New York 1992; Cambridge, MA 1994, no. 54; Newark, DE 2002

LITERATURE: Stetz and Samuels Lasner, *England in the 1890s*, 40, no. 53; Stetz and Samuels Lasner, *Yellow Book*, 62, no. 54

George Eliot [Mary Ann Evans] (1819–1880)

pencil, [ca. 1878]

by George Du Maurier (1834–1896)

13 × 10.8 cm. (5.125 × 4.25 in.)

inscribed "Drawn for me by G. Du Maurier M W Ridley" lower right

PROVENANCE: Matthew White Ridley; English Literature and History, Sotheby's, London, 13 December 1994, no. 75. Acquired: July 1995 from Jarndyce, London

EXHIBITED: *Mothers and Others: Victorian Literary Association Books, Drawings, and Letters from the Collection of Mark Samuels Lasner*, Charles E. Shain Library, Connecticut College, New London, CT, 22 September–30 November 1995, no. 10; Newark, DE 2002

LITERATURE: Mark Samuels Lasner, *Mothers and Others: Victorian Literary Association Books, Drawings, and Letters from the Collection of Mark Samuels Lasner* (New London, CT, 1995), 10, no. 10

Michael Field [Katherine Bradley (1848–1914) and Edith Cooper (1862–1913)]

photograph, silver gelatin (likely a copy of a platino-type), [1884-1889]

by Bromhead, Clifton, Bristol

8.3 × 6.7 cm. (3,25 × 2,625 in.)

PROVENANCE: Henri Locard. Acquired: September 2000 from Maggs Brothers Ltd., London

EXHIBITED: Newark, DE 2002; *Gender and the London Theatre, 1880–1920*, Bryn Mawr College Library, Bryn Mawr, PA, 28 September–19 December 2003; *Michael Field and Their World*, Memorial Hall, University of Delaware, 27-29 February 2004

LITERATURE: Margaret D, Stetz, *Gender and the London Theatre, 1880–1920* (High Wycombe, Bucks., UK, 2004), 56, repro. 57; Ivor C. Treby, *The Michael Field Catalogue: A Book of Lists* (London, 1998), 21, repro. 88

Harry Furniss (1854–1925)

Self-caricature in autograph letter to "My Dear Wallis," 25 September 1901

ink

17.6 × 10.8 cm. (6.925 × 4.5 in.)

ACQUIRED: January 1999 from David J. Holmes Autographs, Hamilton, NY

EXHIBITED: Newark, DE 2002

Sarah Grand [Frances Clarke McFall] (1854–1943) and Sir W. S. [William Schwenck] Gilbert (1836–1911)

photographs by Stereoscopic Co., London, reproduced in [W. T. Stead?], *Notables of Britain: An Album of Portraits and Autographs of the Most Eminent Subjects of*

Her Majesty in the 60th Year of Her Reign (London, 1897)

ACQUIRED: August 2001 from Second Story Books, Washington, DC

EXHIBITED: Newark, DE 2002

John Gray (1866–1934)

lithograph, [1896]

by Charles Haslewood Shannon (1863–1937)

45.1 × 28.7 cm. (17.75 × 11.3 in.)

PROVENANCE: T. Sturge Moore; Henrietta Sturge Moore. ACQUIRED: Sotheby's, London, 6–7 June 1991, part of no. 77, via Max Rutherston, London

EXHIBITED: Newark, DE 2002; Wilmington, DE 2006

LITERATURE: Davies, 44; Delaney, 32, no. 44; Frederick, 8–9; Ricketts, 29, no. 44

Thomas Hardy (1840-1928)

lithographic crayon (recto), sanguine and black crayon (verso), 1897

by Sir William Rothenstein (1872-1945)

26 × 17.5 cm. (10.25 × 6.875 in.)

signed and dated 1897 lower left

PROVENANCE: Rothenstein family. Acquired: January 1983 from Warrack and Perkins, Church Enstone, Oxfordshire

EXHIBITED: Washington, DC 1989-1990, no. 73; New York 1992; Newark, DE 2002

LITERATURE: *The Collected Letters of Thomas Hardy, Vol. 2, 1893-1901*, ed. Richard Little Purdy and Michael Millgate (Oxford, 1980), 149–50; Rothenstein, *Portrait Drawings*, 12–13, nos. 98–99; Rothenstein, *Men and Memories*, 302; Samuels Lasner, *English 'Nineties*, 12; Speaight, 108; Stetz and Samuels Lasner, *England in the 1890s*, 50, no. 73

Henry Harland (1861-1905)

portrait sketch on autograph manuscript poem by Harland

ink, [1882]

by Sarah J. Eddy (1851–1945)

26.7 × 15.2 cm. (10.5 × 6 in.)

signed by Harland (three times) at right

PROVENANCE: Sarah J. Eddy; Donald A. Roberts, by descent; Brattle Book Shop, Boston. Acquired: October 1992 from Thomas G. Boss Fine Books, Boston

EXHIBITED: Newark, DE 2002

Frank Harris (1856-1931)

"Had Shakespeare asked me . . ."

pencil, ink, and watercolor, [1896]

by Sir Max Beerbohm (1872-1956)

32.1 × 20.3 cm. (12.625 × 8 in.) irregular

inscribed with title lower left

PROVENANCE: S. J. Wingate. Acquired: English Illustrated Books and Related Drawings, Sotheby's, London, 1 May 1980, no. 507, via Princeton Rare Books, Princeton, NJ

EXHIBITED: *A Peep Into the Past: Max Beerbohm Caricatures,* Bertha and Karl Leubsdorf Art Gallery, Hunter College, New York,; Delaware Art Museum, Wilmington, DE, 1987; New York 1992; Princeton, NJ 1995, no. 112; Newark, DE 2002; New York and Chestnut Hill, MA 2005

LITERATURE: W. H. Auden, "One of the Family," in *The Surprise of Excellence: Modern Essays on Max Beerbohm,* ed. J. G. Riewald (Hamden, CT, 1974), 170; Bilski and Braun, 54, repro. 55; Cadden and Jensen, 56, no. 112; Cecil, 164; Lawrence Danson, *Max Beerbohm and the Act of Writing* (Oxford, 1989), 162, repro. pl. 19; Martin Fido, *Oscar Wilde* (New York, 1973), 71, repro.; Hart-Davis, 76, no. 720, repro. pl. 51; Lawrence and Nancy Goldstone, *Warmly Inscribed: The New England Forger and Other Book Tales* (New York, 2001), 63–64; Hall, *Max Beerbohm,* 52; Hall, *Max Beerbohm Caricatures,* 31, repro. pl. 15; Roy Huss, "Max Beerbohm's Drawings of Theatrical Figures (II)," *Theatre Notebook* (Spring 1967): 107; Alexandra Mullen, "Max Beerbohm: Spectator Sport," *Hudson Review,* Summer 2003, 396; *A Peep Into the Past: Max Beerbohm Caricatures,* curated and with an essay by N. John Hall (New York,987), 53, repro. pl. 5; Philippa Pullar, *Frank Harris: A Biography* (New York, 1974), 173; J. G. Riewald, *Max Beerbohm's Mischievous Wit: A Literary Entertainment* (Assen, The Netherlands, 2000), 94; Samuels Lasner, *English 'Nineties,* 5

W. E. [William Ernest] Henley (1849-1903)

photograph, silver gelatin, [1899]

by Walter Biggar Blaikie (1847-1928)

19.4 × 15.2 cm. (7.625 × 6 in.)

signed "W. E. Henley 1901" on mount lower right

PROVENANCE: Henley family; Anna Fleming. Acquired: English Literature and History, Sotheby's, London, 13 December 1990, part of no. 99, via Bertram Rota, London

EXHIBITED: Newark, DE 2002

LITERATURE: John Connell, *W. E. Henley* (London, 1949), 340

A. E. [Alfred Edward] Housman (1859-1936)

photograph, platinotype, [ca. 1894]

by Henry Van der Weyde Light Studio, London

9.1 × 5.8 cm. (3.6 × 2.3 in.)

signed "A. E. Housman" on image

ACQUIRED: Summer Autograph Auction, R. M. Smythe, New York, 12 June 1997, no. 194, via David J. Holmes Autographs, Hamilton, NY

EXHIBITED: Newark, DE 2002

LITERATURE: P. G. Naiditch, "Photographs of A. E. Housman," *Housman Society Journal* 26 (2000): 44–45; *The Name and Nature of A. E. Housman: From the Collection of Seymour Adelman* (Bryn Mawr, PA, 1986), 28, no. 32, repro.

Sir Henry Irving (1838-1905)

A Visitor to the Rehearsal

ink over pencil (recto), pencil preparatory sketch (verso), [1893]

by Aubrey Beardsley (1872-1898)

17.8 × 10.5 cm. (7 × 4.125 in.)

inscribed with title (crossed out) lower left, instructions to the printer (not by Beardsley) across bottom; verso inscribed (not by Beardsley) "PMG 8633"

PROVENANCE: G. R. Halkett; possibly owned by Oscar Wilde and then by his son, Vyvyan Holland; David Gage Joyce; Literary and Historical Manuscripts, Autographs, Books . . . The Collection formed by the Late David Gage Joyce, Hanzel Galleries, Chicago, 23-24 September 1973, no. 80. Acquired: January 1987 from Warrack and Perkins, Church Enstone, Oxfordshire

EXHIBITED: *Mothers and Others: Victorian Literary Association Books, Drawings, and Letters from the Collection of Mark Samuels Lasner,* Charles E. Shain Library, Connecticut College, New London, CT, 22 September–30 November 1995, no. 3; *Beautiful Decadence,* Isetan Museum of Art, Tokyo; Nara Sogo Museum of Art, Nara; Museum of Fine Arts. Gifu, 1997–1998, no. 5; Newark, DE 2002

LITERATURE: *Beautiful Decadence: Aubrey Vincent Beardsley, Charles Ricketts, Laurence Housman, Harry Clark, Alastair, Sidney Herbert Sime, Willy Pogany, Arthur Rackham* (Tokyo, 1997), 30, no. 5, repro.; *The Early Work of Aubrey Beardsley* (London, 1899), repro. 153; A. E. Gallatin, *Aubrey Beardsley's Drawings: A Catalogue, With a List of Criticisms* (New York, 1903), 18; A. E. Gallatin. *Aubrey Beardsley: Catalogue of Drawings and Bibliography* (New York, 1945), 32, no. 274; "A Royal College of Music Performance: 'Orpheus' at the Lyceum," *Pall Mall Budget,* 16 March 1893, repro. 395; Mark Samuels Lasner, *Mothers and Others: Victorian Literary Association Books, Drawings, and Letters from the Collection of Mark Samuels Lasner* (New London, CT, 1995), 6, no. 3; John Stokes, *Oscar Wilde: Myths, Miracles*

and Imitations (Cambridge, 1996), 118; Aymer Vallance, "List of Drawings by Aubrey Beardsley," in Aubrey Beardsley, *A Book of Fifty Drawings* (London, 1897), 204; Aymer Vallance, "List of Drawings by Aubrey Beardsley," in Robert Ross, *Aubrey Beardsley* (London, 1909), 75, no. 55.IX.3; Warrack and Perkins, *Catalogue 66: 19th and 20th Century Books, Prints and Drawings* (Church Enstone, Oxon., UK, 1987), 4, no. 5, repro. 5

Sir Henry Irving [1838-1905]

painting, *Arrangement in Black, No. 3: Sir Henry Irving as Philip II of Spain* (1876–1885), by James McNeill Whistler (1834-1903), reproduced as frontispiece in Henry Irving, *The Drama: Addresses* (London, 1893)

PROVENANCE: Thomas Hardy (with his ownership signature and "Max Gate" book label); W. Heffer and Sons, Cambridge, UK. Acquired: January 1988 from David J. Holmes Autographs, Hamilton, NY

EXHIBITED: Newark, DE 2002

LITERATURE: Don C. Seitz, *Writings by & about James Abbott McNeill Whistler: A Bibliography* (Edinburgh, 1910), 34, no. 55; Andrew McLaren Young, Margaret MacDonald, Robin Spencer, and Hamish Miles, *The Paintings of James McNeill Whistler* (New Haven, CT, 1980), 1:109–10, repro. 2:pl. 408

Henry James (1843-1916)

lithograph, 1898
by Sir William Rothenstein (1872-1945)
37.5 × 25.4 cm. (14.75 × 10 in.)
signed and dated in the stone at left

PROVENANCE: Sir John Rothenstein?; Michael Parkin Gallery, London. Acquired: May 1989 from Max Rutherston, London

EXHIBITED: Washington, DC 1989-1990, no. 91; Newark, DE 2002

LITERATURE: Kilmurray, 103; Rothenstein, *Portrait Drawings*, 100, no. 87, repro. pl. 33; Rothenstein, *Men and Memories*, 304, repro. pl. facing 304; Speaight, 111-12, 115; Stetz and Samuels Lasner, *England in the 1890s*, 60, no. 91

Rudyard Kipling (1865-1936)

Self-Portrait
pencil, [1890]
20.3 × 12.7 cm. (8 × 5 in.)
inscribed "Sincerely yours Rudyard Kipling"
with accompanying autograph letter to Helen Bartlett Bridgman, 29 June [1890]

PROVENANCE: Helen Barrett Bridgman. Acquired: January 1994 from David J. Holmes Autographs, Hamilton, NY

EXHIBITED: Newark, DE 2002

Richard Le Gallienne (1867-1947)

bookplate of Richard Le Gallienne
wood engraving, [ca. 1892–94]
by Alan Wright (fl. 1889-1925)
tipped in Richard Le Gallienne, *Volumes in Folio* (London, 1889)
9.5 × 7.8 cm. (3.75 × 3.065 in.)
signed with monogram in the plate lower right

PROVENANCE: J. Rogers Rees (book presented by Le Gallienne, March 1889); James Milne-Cooper. Acquired: July 1980 from Holleyman and Treacher, Brighton, Sussex

EXHIBITED: Washington, DC 1989-1990, no. 3; Newark, DE 2002

LITERATURE: Henry W. Fincham, *Artists and Engravers of British and American Book Plates: A Book of Reference for Book Plate and Print Collectors* (London, 1897), 109; Walter Hamilton, *Odd Volumes and Their Book-Plates* (London, 1899), 23–24, repro. pl. facing 28; Stetz and Samuels Lasner, *England in the 1890s*, 3, no. 3, repro. pl. 1

Richard Le Gallienne (1867-1947)

Mr. Richard Le Gallienne
ink and wash, [ca. 1900]
by Sir Max Beerbohm (1872-1956)
21. 6 × 33 cm. (8.5 × 13 in.)
signed "Max" at left, titled at right

PROVENANCE: Leicester Galleries, London; Charles Scribner's Sons, New York; Leroy Arthur Sugarman. Acquired: March 1996 from Glenn Horowitz Bookseller, Inc., New York

EXHIBITED: *Max in Retrospect*, Leicester Galleries, London, May 1952, no. 7; Washington, DC 1989-1990, no. 110; Newark, DE 2002

LITERATURE: Leicester Galleries, *Catalogue of an Exhibition of Drawings by Max Beerbohm Entitled "Max" in Retrospect* (London, 1952), 5, no. 7; Hart-Davis, 91, no. 918; Stetz and Samuels Lasner, *England in the 1890s*, 73, no. 110, repro. pl. 16

Caroline Blanche, Lady Lindsay (née Fitzroy)(1844-1912)

pencil, 1873
by George James Howard, Ninth Earl of Carlisle (1843-1911)
34.9 × 24.8 cm. (13.75 × 9.75 in.)
signed with initials and titled "Blanche Lindsay Naworth August 1873" upper right

PROVENANCE: Howard family. Acquired: June 1995

from Christopher Wood Gallery, London

EXHIBITED: Newark, DE 2002

Violet Manners (née Lindsay), *Duchess of Rutland* (1856-1937)
The Marchioness of Granby
lithograph, 1897
by Sir William Rothenstein (1872-1945)
38.1 × 27.9 cm. (15 × 11 in.)
signed and dated in the stone at right
PROVENANCE: Rothenstein family. Acquired: English Illustrated and Private Press Books, Sotheby's, London, 26 October 1978, part of no. 561, via Seven Gables Bookshop, New York
EXHIBITED: Newark, DE 2002
LITERATURE: Rothenstein, *Portrait Drawings*, 97, no. 65, repro. pl. 17; Rothenstein, *Men and Memories*, 296; Speaight, 108, 114

Phil May (1864-1903)
Self-Portrait
ink, 1901
20 × 13.6 cm. (7.875 × 5 in.)
inscribed "Yours sincerely Phil May April 15. 1901" at right
ACQUIRED: November 2001 from Rodney Engen Fine Art, London
EXHIBITED: Newark, DE 2002

George Meredith (1828-1909)
photograph, platinotype, [1890]
by Frederick Hollyer (1837-1933)
14.3 × 9.8 cm. (5.65 × 3.875 in.)
signed "George Meredith Sep. 6th. 1890"
ACQUIRED: March 1994 David O'Neil, Boston, MA
EXHIBITED: Newark, DE 2002
LITERATURE: Kilmurray, 141; Jeremy Maas, *The Victorian Art World in Photographs* (London, 1984), 221, no. 423

Alice Meynell (1847-1922)
lithograph, 1897
by Sir William Rothenstein (1872-1945)
17.5 × 24.1 cm. (14.75 × 9.5 in.)
signed and dated in the stone upper left
PROVENANCE: Rothenstein family. Acquired: English Illustrated and Private Press Books, Sotheby's, London, 26 October 1978, part of no. 561, via Seven Gables Bookshop, New York
EXHIBITED: Washington, DC 1989-1990, no. 44;

Newark, DE 2002
LITERATURE: Kilmurray, 142; Rothenstein, *Portrait Drawings*, 99, no. 83; Stetz and Samuels Lasner, *England in the 1890s*, 34, no. 44

T. [Thomas] Sturge Moore (1870-1944)
The Modeller
lithograph, [1891]
by Charles Haslewood Shannon (1863-1937)
18.6 × 19 cm. (7.325 × 7.5 in.)
signed with circular monogram in the stone at right
PROVENANCE: T. Sturge Moore; Henrietta Sturge Moore. Acquired: Illustrated Books, Children's Books, Conjuring, and Related Drawings, Sotheby's, London, 6–7 June 1991, part of no. 77, via Max Rutherston, London
EXHIBITED: Newark, DE 2002; Wilmington, DE 2006
LITERATURE: Davies, 75; Delaney, 21, no. 6; Frederick, 6; Ricketts, 22, no. 6

Jane Morris (née Burden) (1840-1914)
Mrs. William Morris
pencil, [1870]
by Dante Gabriel Rossetti (1828-1882)
36.8 × 30.5 cm. (14.5 × 12 in.)
PROVENANCE: The Remaining Works by the Painter and Poet Dante Gabriel Rossetti, Christie's, London, 12 May 1883, no. 192?; William Michael Rossetti; K. Gregory, New York; Howard S. Mott, Inc. Sheffield, MA; William Turner Levi; Black Sun Books, New York; Jenkins Company, Austin, TX. Acquired: February 1978 from George S. MacManus Co., Philadelphia
EXHIBITED: *Collectors Collected*, Brockton Art Center-Fuller Memorial, Brockton, MA, 7 June–15 August 1979; *La Bella Mano: Pre-Raphaelite Paintings and Decorative Arts from the Samuel and Mary R. Bancroft Collection of the Delaware Art Museum with Additional Works from Other Collections*, Virginia Museum, Richmond, VA, 14 September–24 October 1982. no. 34; Charlottesville, VA 1985, no. 50; *Being William Morris*, Morgan Library, New York, 8 May–1 September 1996; New York 1996-1997, no. 28; Newark, DE 2002
LITERATURE: Jenkins Company, *Art and Art Objects* (Austin, TX, 1978), 24, no. 40, repro.; Debra N. Mancoff, *Jane Morris: The Pre-Raphaelite Model of Beauty* (San Francisco, 2000), repro. 62; Debra N. Mancoff, "Seeing Mrs. Morris: Photographs of Jane Morris from the Collection of Dante Gabriel Rossetti," *Princeton University Library Chronicle* (Spring 2001): 295, repro. 294; Samuels Lasner, *William Morris*, 13, no. 28; Stetz and Mark Samuels Lasner, *England in the*

1880s, 31–32, no. 50; Virginia Surtees, *The Paintings and Drawings of Dante Gabriel Rossetti (1828–1882): A Catalogue Raisonné* (Oxford, 1971), 1:178, no. 385; Virginia Museum, *La Bella Mano: Pre-Raphaelite Paintings and Decorative Arts from the Samuel and Mary R. Bancroft Collection of the Delaware Art Museum, with Additional Works from Other Collections* (Richmond, VA, 1982), 16, no. 34

William Morris (1834-1896) with *May Morris* (1862-1938) and members of the Hammersmith Branch of the Socialist League
photograph, albumen, [1885–1889]
attributed to Frederick Hollyer (1837-1933)
20.3 × 26.7 cm. (8 × 10.5 in.)
ACQUIRED: July 1996 from Biblion, London, via Bertram Rota, London
EXHIBITED: New York 1996-1997, no. 76; Newark, DE 2002
LITERATURE: Fiona MacCarthy, *William Morris: A Life for Our Time* (London, 1994), repro. in group of pls. following 556; Linda Parry, ed., *William Morris* (London, 1996), 67, no. E.4, repro. fig. 27; Samuels Lasner, *William Morris*, 19, no. 76

E. [Edith] Nesbit (1858-1924)
photograph, silver gelatin, with sepia toning, [ca. 1901]
15 × 10.8 cm. (5.925 × 4.25 in.)
Acquired: July 1998 from Holleyman and Treacher, Brighton, Sussex
EXHIBITED: Washington, DC 1989-1990, no. 40; Newark, DE 2002
LITERATURE: Linda Hughes, ed., *New Woman Poets: An Anthology*, Lost Chords series (London, 2001), repro. pl. facing 43; Stetz and Samuels Lasner, *England in the 1890s*, 31, no. 40

Ida Nettleship (1877-1907)
Ida, Standing Before a Fireplace
pencil, [ca. 1899-1900]
by Augustus John (1878-1961)
31.1 × 18.4 cm. (12.25 × 7.25 in.)
signed "John" lower left
PROVENANCE: Cass Canfield; Thos. Agnew and Sons, London; Wendy Burden Morgan; Nineteenth Century European Paintings, Drawings and Watercolors, Christie's, New York, 30 October 1985, no. 465; Thos. Agnew and Sons, London. Acquired: August 1987 from Spink, London
EXHIBITED: *Modern British Paintings, Watercolours, Drawings, Sculpture, and Prints*, Thos. Agnew and Sons, London, March 1986, no. 42; *20th Century British*

Paintings, Watercolours, and Drawings, Spink and Sons, London, 4–26 June 1986; Newark, DE 2002

Walter Pater (1839-1894)
lithograph, 1894
by Sir William Rothenstein (1872-1945)
in William Rothenstein, *Oxford Characters: Twenty-four Lithographs, with Text by F. York Powell, and Others* (London, 1896)
48.6 × 30.5 cm. (19.125 × 12 in.)
signed and dated in the stone lower right, additionally signed in ink below image
PROVENANCE: Francis Burdett Money-Coutts, fifth Baron Latymer (*Oxford Characters* presented by publisher, John Lane, Christmas 1896). Acquired: April 1984 from Warrack and Perkins, Church Enstone, Oxfordshire
EXHIBITED: Washington, DC 1989-1990, no. 89; Newark, DE 2002
LITERATURE: Kilmurray, 161; James G. Nelson, *The Early Nineties: A View from the Bodley Head* (Cambridge, MA, 1971), 292–93, also 287, no. 59; James G. Nelson, *A Checklist of Early Bodley Head Books, 1889–1894* (Oxford, 1999), 49, no. 1893.23; *Letters of Walter Pater*, ed. Lawrence Evans (Oxford, 1970), 150-52; Rothenstein, *Portrait Drawings*, 91, no. 18, repro. pl. 4; Rothenstein, *Men and Memories*, 155–56, repro. pl. facing 145; Speaight, 58-59, 97; Stetz and Samuels Lasner, *England in the 1890s*, 59, no. 89; Samuel Wright, *A Bibliography of the Writings of Walter H. Pater* (New York, 1975), 49–50

Joseph Pennell (1857-1926)
Letter L (Self-Portrait of the Artist, Seated)
ink, [ca. 1890-1900]
14.6 × 17.1 cm. (5.75 × 6.75 in.)
inscribed with publisher's notations on mount
PROVENANCE: Century Company, New York. Acquired: August 1984 from James Cummins, Bookseller, New York
EXHIBITED: Newark, DE 2002
LITERATURE: James Cummins, Bookseller, *Catalogue 45: Original Illustrations and Works of Art* (New York, 1984), 30, repro.

Lucien Pissarro (1863-1944)
lithograph, [1895]
by Charles Haslewood Shannon (1863-1937)
31.7 × 25.4 cm. (12.5 × 10 in.)
signed with initials in the stone at right
PROVENANCE: T. Sturge Moore; Henrietta Sturge Moore. Acquired: Illustrated Books, Children's Books,

Conjuring, and Related Drawings, Sotheby's, London, 6–7 June 1991, part of no. 77, via Max Rutherston, London

EXHIBITED: Newark, DE 2002; Wilmington, DE 2006

LITERATURE: Delaney, 28, no. 32; Frederick, 6, repro. 7; Ricketts, 27, no. 32

Charles de Sousy Ricketts (1866–1931)

The Wood-Engraver

lithograph, [1894]

by Charles Haslewood Shannon (1863-1937)

24.7 × 29.8 cm. (9.75 × 11.75 in.)

signed with monogram in the stone at right

PROVENANCE: T. Sturge Moore; Henrietta Sturge Moore. Acquired: Illustrated Books, Children's Books, Conjuring, and Related Drawings, Sotheby's, London, 6–7 June 1991, part of no. 77, via Max Rutherston, London

EXHIBITED: Newark, DE 2002; Wilmington, DE 2006

LITERATURE: Davies, 91; Delaney, 26, no. 28; Frederick, 5; Ricketts, 26, no. 28

W. [Walford] Graham Robertson (1866-1948)

photograph, matte collodion cabinet card, [early 1890s]

by H. and R, Stiles, London

14.6 × 10.1 cm. (5.75 × 4 in.)

PROVENANCE: W. Graham Robertson; Kerrison Preston; English Illustrated Books of the 19th and 20th Centuries, Sotheby's, London, 10 March 1975, part of no. 128. Acquired: March 1999 from Justin G. Schiller Ltd., New York

EXHIBITED: Newark, DE 2002

W. [Walford] Graham Robertson (1866-1948) with members of the Loony Club, including *H. J. [Henry Justice] Ford* (1860-1940) and *J. W. [John William] Mackail* (1859-1945)

photograph, albumen, [ca. 1890]

10.7 × 14.4 cm. (4.2 × 5.675 in.)

inscribed with names of subjects

PROVENANCE: W. Graham Robertson; Kerrison Preston; English Illustrated Books of the 19th and 20th Centuries, Sotheby's, London, 10 March 1975, part of no. 128. Acquired: March 1999 from Justin G. Schiller Ltd., New York

EXHIBITED: Newark, DE 2002

Dante Gabriel Rossetti (1828-1882)

photograph, albumen carte-de-visite, [1862-1863]

by W. and D. Downey, London

in Algernon Charles Swinburne's photograph album

12.6 × 6.3 cm. (4.0625 × 2.5 in.)

PROVENANCE: Algernon Charles Swinburne; E. E. Bissell: English Literature and History, Sotheby's, London, 15 July 1998, no. 373. Acquired: August 1998 from Roy Davids, Great Haseley, Oxfordshire

EXHIBITED: Newark, DE 2002

LITERATURE: *The Correspondence of Dante Gabriel Rossetti: The Chelsea Years, 1863–1872, Prelude to Crisis, Vol. 3, 1863–1867*, ed. William E. Fredeman (Woodbridge, Suffolk, UK, 2003), repro. frontispiece; Kilmurray, 180; Rikky Rooksby, "Two Swinburne Photograph Albums," *Victorian Poetry* (Winter 1999): 549–51

Sir William Rothenstein (1872-1945)

Self-Portrait, Aged 17

charcoal and white chalk on brown paper, 1889

29.2 × 23.5 cm. (11.5 × 9.25 in.)

signed and dated lower right

PROVENANCE: Sir John Rothenstein; Anthony d'Offay, London; Spink, London. Acquired: October 1988 from Max Rutherston, London

EXHIBITED: *Summer Exhibition 1988*, Spink and Sons, London, June 1988; Washington, DC 1989-1990, no. 92; Newark, DE 2002; New York and Chestnut Hill, MA 2005

LITERATURE: Stetz and Samuels Lasner, *England in the 1890s*, 61, no. 92

Sir William Rothenstein (1872-1945) and others, including *Aubrey Beardsley* (1872-1898), *Charles Furse* (1868-1904), *George Moore* (1852-1933), *Sir Arthur Wing Pinero* (1855-1934), *Archibald Philip Primrose, Fifth Earl of Rosebery* (1847-1929), *Oscar Wilde* (1854-1900)

Will Rothenstein Laying Down the Law

ink, colored chalks, and wash, [ca. 1895]

by Sir Max Beerbohm (1872-1956)

30.2 × 24.1 cm. (11.875 × 9.5 in.)

signed "Max" lower left, inscribed with captions to each caricature subject

PROVENANCE: Charles Rutherston; his daughter, Mrs. Christopher Powell. Acquired: November 1991 from Max Rutherston, London

EXHIBITED: *Max in Retrospect*, Leicester Galleries, London, May 1952, no. 49; *William Rothenstein*, Max Rutherston, London, 27 February–16 March 1990; New York 1992; Cambridge, MA 1994, no. 41; Newark, DE 2002; New York and Chestnut Hill, MA 2005

LITERATURE: Robert S. Becker, "Artists Look at George Moore," *Irish Arts Review* (Winter 1985): 56, no. 3: Bilski and Braun, 51, repro. 52; Bradford City Art

Gallery and Museums, *Sir William Rothenstein, 1872–1945: A Centenary Exhibition* (Bradford, Yorks., UK, 1972), repro. pl. facing 8; Hart-Davis, 121, no. 1307; Mary M. Lago and Karl Beckson, ed., *Max and Will: Max Beerbohm and William Rothenstein: Their Friendship and Letters, 1893–1945* (London, 1975), repro. in group of pls. following 42; Leicester Galleries, *Catalogue of an Exhibition of Drawings by Max Beerbohm Entitled "Max" in Retrospect* (London, 1952), 10, no. 49;Samuels Lasner, *English 'Nineties*, 5, repro. 2; Stetz and Samuels Lasner, *Yellow Book*, 61, no. 41

John Singer Sargent (1856-1925)

lithograph, [1897]
by Sir William Rothenstein (1872-1945)
36.5 × 24.1 cm. (14.35 × 9.5 in.)
PROVENANCE: Rothenstein family. Acquired: English Illustrated and Private Press Books, Sotheby's, London, 26 October 1978, part of no. 561, via Seven Gables Bookshop, New York
EXHIBITED: Newark, DE 2002; New York and Chestnut Hill, MA 2005
LITERATURE: Bilski and Braun, 187, repro. 187; Kilmurray, 185; Rothenstein, *Portrait Drawings*, 96, no. 54, pl. 19; Rothenstein, *Men and Memories*, 304–5, repro. pl. facing 193; Speaight, 115, repro. pl. 2(b)

Olive Schreiner (1855-1920)

photograph, reproduced as frontispiece in Olive Schreiner, *Dreams* (London, 1891)
PROVENANCE: Arthur Symons; Katherine Willard (book presented by Symons, January 1892)
EXHIBITED: Newark, DE 2002
LITERATURE: G. Krishnamurti, comp., *Women Writers of the 1890's* (London, 1991), 118

George Bernard Shaw (1856-1950)

photograph, silver gelatin, [1893]
by Sir Emery Walker (1851-1933)
7.3 × 9.5 cm. (2.875 × 3.75 in.)
dated by Shaw "26/3/93" on verso
PROVENANCE: George Bernard Shaw; his cousin, Georgina (Judy) Gillmore. Acquired: February 1997 from Bertram Rota, London
EXHIBITED: Newark, DE 2002

George Bernard Shaw (1856-1950)

lithograph, 1897
by Sir William Rothenstein (1872-1945)
from William Rothenstein, *English Portraits: A Series of Lithographed Drawings* (London, 1898)
37.5 × 24.1 cm. (14.75 × 9.5 in.)

signed and dated in the stone lower right
PROVENANCE: Rothenstein family. Acquired: English Illustrated and Private Press Books, Sotheby's, London, 26 October 1978, part of no. 561, via Seven Gables Bookshop, New York
EXHIBITED: *The Wilde Years: Oscar Wilde & The Art of His Times*, Barbican Art Gallery, London, 5 October 2000–14 January 2001, no. 148; Newark, DE 2002
LITERATURE: Rothenstein, *Portrait Drawings*, 99, no. 81; *The Wilde Years: Oscar Wilde & the Art of His Time*, ed. and with text by Tomoko Sato and Lionel Lambourne (London, 2000), 119, no. 148, repro. 44

Walter Sickert (1860-1942)

Self-Portrait
ink and wash on buff paper, [1897]
25.4 × 20.3 cm. (10 × 8 in.)
signed and inscribed "Sickert inv. et del." lower left
PROVENANCE: A. C. R. Carter; Sir John and Lady Witt; Drawings, Watercolours, and Paintings from the Collection of the Late Sir John and Lady Witt, Sotheby's, London,19 February 1987, no. 383. Acquired: Twentieth Century British Art, Christie's, London, 6 November 1998, no. 180, via Bertram Rota, London
EXHIBITED: Newark, DE 2002
LITERATURE: Wendy Baron, *Sickert* (London, 1973), 53, 54, 315, no. 95, repro. pl. 63; Wendy Baron and Richard Shone, ed., *Sickert Paintings* (London, 1992), 120, repro. fig. 41; A. C. R. Carter, ed., *The Year's Art 1898* (London, 1898), repro. pl. facing 132; A. C. R. Carter, "The Year's Art, 1942–4," in *The Year's Art, 1942–1944*, comp. A. C. R. Carter (London, 1946), xx; Ronald Pickvance, "Sickert's Portrait of Zangwill," in "Letters to the Editor," *Listener*, 24 August 1961, 281–82

Algernon Charles Swinburne (1837-1909)

pencil, 1860
by Dante Gabriel Rossetti (1828-1882)
25.4 × 22.2 cm. (10 × 8.75 in.)
inscribed "Aug. 1860" lower right
PROVENANCE: The Remaining Works of the Painter and Poet Dante Gabriel Rossetti, Christie's, London, 12 May 1883, no. 142; Fawcett; Frederick Keppel and Co., New York; George Allison Armour; his son, William Armour; Dorothy T. Armour; Important 19th Century European Paintings, Drawings and Watercolors, Sotheby's, New York, 24 May 1984, no. 236. Acquired: Victorian Pictures, Sotheby's, London, 6 November 1995, no. 212, via Roy Davids, Great Haseley, Oxfordshire
EXHIBITED: Newark, DE 2002
LITERATURE: *The Correspondence of Dante Gabriel Rossetti: The Formative Years, 1855–1862, Vol. 2,*

1855–1862, ed. William E. Fredeman (Woodbridge, Suffolk, UK, 2002), 285; Lawrence Danson, *Max Beerbohm and the Mirror of the Past* (Princeton, NJ, 1982), 34, 38; Alastair Grieve, "Rossetti and the Scandal of Art for Art's Sake in the Early 1860s," in *After the Pre-Raphaelites: Art and Aestheticism in Victorian England*, ed. Elizabeth Prettejohn (New Brunswick, NJ, 1999), 18, repro. fig. 1; H. C. Marillier, *Dante Gabriel Rossetti: An Illustrated Memorial of His Art and Life* (London, 1899), 259, no. 342; Elizabeth Prettejohn, *Rossetti and His Circle* (New York, 1997), 38, repro. fig. 32; Duncan Robinson and Stephen Wildman, *Morris & Company at Cambridge* (Cambridge, 1980), 9; W. M. Rossetti, *Dante Gabriel Rossetti as Designer and Writer* (London, 1889), 277, no. 134; W. M. Rossetti, *Some Reminiscences* (London, 1906), repro. pl. facing 1:218; Virginia Surtees, *The Paintings and Drawings of Dante Gabriel Rossetti (1828–1882): A Catalogue Raisonné* (Oxford, 1971), 1:198, no. 522; Arthur Symons, *Dante Gabriel Rossetti* (London, 1909), repro. 52

Algernon Charles Swinburne (1837-1909)

Mr. Swinburne

ink and wash, 1899

by Sir Max Beerbohm (1872-1956)

28.9 × 20 cm. (11.375 × 7.875 in.)

signed "Max" upper right, inscribed with title and dated June 1899 lower left

PROVENANCE: Philip Guedalla; Mrs. Philip Guedalla. Acquired: British and Irish Traditionalist and Modernist Paintings, Watercolours, Drawings and Sculpture, Christie's, London, 10 June 1988, no. 153, via Max Rutherston, London

EXHIBITED: *Drawings by Max Beerbohm and Mrs. Newton*, Oxford Arts Club, November 1922, no. 2; *Exhibition of Caricatures by Max Beerbohm, Lent by Mr. Philip Guedalla*, Arts Club of Chicago, Chicago, 4-27 January 1938, no. 29; *The Philip Guedalla Collection of Caricatures by Max Beerbohm*, Leicester Galleries, London, September-October 1945, no. 54; New York 1992; Newark, DE 2002

LITERATURE: Arts Club of Chicago, *Exhibition of Caricatures by Max Beerbohm, Lent by Mr. Philip Guedalla* (Chicago, 1938), 6, no. 29; John Felstiner, *The Lies of Art: Max Beerbohm's Parody and Caricature* (New York, 1972), 109–10; Ira Grushow, *The Imaginary Reminiscences of Sir Max Beerbohm* (Athens, OH, 1984), 63–64; Hall, *Max Beerbohm*, 186, repro. pl. 13; Hart-Davis, 146, no. 1642, repro. pl. 44; Leicester Galleries, *Catalogue of the Philip Guedalla Collection of Caricatures by Max Beerbohm* (London, 1945), 10, no. 54; Bohun Lynch, *Max Beerbohm in Perspective* (London, 1921), 131–32; Bohun Lynch, *A History of Caricature* (London, 1926), 102, repro. pl. 14;

Oxford Arts Club, *Catalogue of Drawings by Max Beerbohm and Mrs. Newton* (Oxford, 1922), 1 J. G. Riewald, *Sir Max Beerbohm: Man and Writer* (The Hague, 1953), 18; Samuels Lasner, *English 'Nineties*, 5

Alfred, Lord Tennyson (1809-1892)

oil on panel, [ca. 1865-1870]

by Charles Lucy (1814-1873)

23.7 × 18.4 cm. (9.325 × 7.25 in.)

signed with monogram lower right

PROVENANCE: Roy Davids. Acquired: English Literature, Sotheby's, London, 21–22 July 1983, no. 299, via Bertram Rota, London

EXHIBITED: *Faces and Places in Literature: A Collection of Portraits and Pictures Formed and Catalogued by Roy Davids*, Thirlstaine House, Cheltenham, 11-17 October 1982, no. 144; Charlottesville, VA 1985, no. 5; Newark, DE 2002

LITERATURE: Roy Davids, *Faces and Places in Literature: A Collection of Portraits and Pictures Formed and Catalogued by Roy Davids, Exhibited at Thirlstaine House, Cheltenham, 11-17 October 1982* (n.p., 1982), 48, no. 144; Stetz and Samuels Lasner, *England in the 1880s*, 12, no. 5

Alfred, Lord Tennyson (1809-1892)

Alfred Tennyson (The Dirty Monk)

photograph, albumen, [1865]

by Julia Margaret Cameron (1815–1879)

25.4 × 20.3 cm. (10 × 8 in.)

signed on mount and inscribed "From Life Registered Photograph" and "For W. Brookfield," also with printed signature of Alfred Tennyson; inscribed "Do not show Tennyson but show Mr. Brookfield" on verso of mount

PROVENANCE: William Henry Brookfield (presented by Cameron). Acquired: Photographs, Christie's, New York, 22 October 2002, part of no. 2, via Hans P. Kraus, Jr. Inc. Fine Photographs, New York

EXHIBITED: *The Auroral Light: Photographs by Women from Grolier Club Member Collections*, Grolier Club, New York, 13 May–2 August 2003

LITERATURE: Julian Cox and Colin Ford, *Julia Margaret Cameron: The Complete Photographs* (Los Angeles, 2003), 355, no. 796; Colin Ford, *Julia Margaret Cameron: 19th Century Photographer of Genius* (London, 2003), 48, repro. 102; Anne H. Hoy and Kimball Higgs, *The Auroral Light: Photographs by Women from Grolier Club Member Collections* (New York, 2003), 7, 15, repro. 6; Kilmurray, 204; Victoria Olsen, *From Life: Julia Margaret Cameron and Victorian Photography* (London, 2003), 120-21, repro.

Dame Ellen Terry (1847-1928)

Ellen Terry as Olivia

pencil, 1878

by Violet Manners (née Lindsay), Duchess of Rutland (1856-1937)

23.2 × 17.8 cm. (9.125 × 7 in.)

signed with monogram lower right, inscribed "E. T. 'Olivia' July 1878" on mount

ACQUIRED: English Drawings and Watercolours, Christie's, London, 28 April 1987, no. 234, via Warrack and Perkins, Church Enstone, Oxfordshire

EXHIBITED: *A Struggle for Fame: Victorian Women Artists and Authors*, Yale Center for British Art, New Haven, 1 March–8 May 1994; New York 2001-2002; Newark, DE 2002

LITERATURE: Susan P. Casteras and Linda H. Peterson, *A Struggle for Fame: Victorian Women Artists and Authors* (New Haven: CT, 1994), 63

Victoria, Queen of Great Britain (1819-1901)

frontispiece in Queen Victoria, *More Leaves from the Journal of a Life in the Highlands, from 1862 to 1882* (London, 1884)

engraving, "improved" in pencil and watercolor

by Sir Max Beerbohm (1872-1956)

PROVENANCE: Elizabeth Beerbohm; Sir Max Beerbohm; Elizabeth, Lady Beerbohm (née Jungmann); The Library and Literary Manuscripts of the Late Sir Max Beerbohm, Sotheby's, London, 12–13 December 1960, no. 234; Bernard Quaritch, London; Robert Lang. Acquired: November 1999 from Serendipity Books, Berkeley, CA

EXHIBITED: Newark, DE 2002

LITERATURE: S. N. Behrman, *Portrait of Max* (New York, 1960), 89-90, 93-97, 102; Cecil, 373-375; H. J. Jackson, *Marginalia: Readers Writing in Books* (New Haven, CT, 2001), 219; Katherine Lyon Mix, *Max and the Americans* (Brattleboro, VT, 1974), 181; Sotheby and Co., *Catalogue of the Library and Literary Manuscripts of the Late Sir Max Beerbohm* (London:, 1960), 65–66, no. 234

H. G. [Herbert George] Wells (1866-1946)

pencil and black crayon, [ca. 1900]

by Edmund J. Sullivan (1869-1933)

25.1 × 19.4 cm. (9.875 × 7.625 in.)

signed with initials lower right

PROVENANCE: James M. W. Borg, Inc. Acquired: Fine Books and Manuscripts, Leslie Hindman Auctioneers, Chicago, 13-14 October 1984, no. 613, via David J. Holmes Autographs, Hamilton, NY

EXHIBITED: Washington, DC 1989-1990, no. 105; Newark, DE 2002

LITERATURE: James M. W. Borg, Inc., *Gallery: Portraits of Literary and Historical Figures* (Chicago, 1982), no. 116, repro.; Stetz and Samuels Lasner, *England in the 1890s*, 69–70, no. 105

James McNeill Whistler (1834-1903)

ink, 1890

by Sydney Starr (1857-1925) and James McNeill Whistler (1834-1903)

23.9 × 19 cm. (8.625 × 7.5 in.)

signed with Whistler's "butterfly" lower left, dated upper right

PROVENANCE: Pickford Waller. Acquired: July 1985 from Michael Parkin Fine Art Ltd., London

EXHIBITED: *Artists of The Yellow Book and the Circle of Oscar Wilde*, Clarendon and Parkin Galleries, London, 5 October–4 November 1983, no. 313; *In Pursuit of the Butterfly: Portraits of James McNeill Whistler*, National Portrait Gallery, Washington, DC, 7 April–13 August 1995; *The Wilde Years: Oscar Wilde and The Art of His Times*, Barbican Art Gallery, London, 5 October 2000–16 January 2001, no. 174; Newark, DE 2002

LITERATURE: Clarendon and Parkin Galleries, *Artists of The Yellow Book and the Circle of Oscar Wilde* (London, 1983), 86, no. 313; Eric Denker, *In Pursuit of the Butterfly: Portraits of James McNeill Whistler* (Washington, DC, 1995), 132, repro. fig. 5:2; A. E. Gallatin, *The Portraits and Caricatures of James McNeill Whistler: An Iconography* (London, 1913), 32-33, no. 91, repro. in group of pls. following 39; A. E. Gallatin, *Portraits of Whistler: A Critical Study and an Iconography* (New York, 1918), 18, 42-43, no. 74, repro. in group of pls. following 44; *The Wilde Years: Oscar Wilde and the Art of His Time*, ed. and with text by Tomoko Sato and Lionel Lambourne (London, 2000), 126, no. 174, repro. 127

James McNeill Whistler (1834-1903)

woodcut, heightened with watercolor, [1897]

by Sir William Nicholson (1872-1949)

25.4 × 22.5 cm. (10 × 8.875 in.)

signed (?) in plate lower right, signed and numbered on mount, inscribed "To be framed in thinnest black. WN" verso

PROVENANCE: A. E. Gallatin; Gallatin family. Acquired: January 1998 from Amy Wolf Fine Art, New York

EXHIBITED: *Collection A. E. Gallatin: Modern Paintings, Drawings, &C.*, Bourgeois Galleries, New York, 2 January–2 February 1918, no. 89; Newark, DE 2002; *Whistleriana: Works by and about James McNeill Whistler from the Collection of Martin Hutner*, Grolier

Club, New York, 10 September–7 November 2003

LITERATURE: Bourgeois Galleries, *Collection A. E. Gallatin: Modern Paintings, Drawings, &C.* (New York, 1918), 18, no. 89; Colin Campbell, *William Nicholson: The Graphic Work* (London, 1992), 62–65, 180, no. 22a; Eric Denker, *In Pursuit of the Butterfly: Portraits of James McNeill Whistler* (Washington, DC, 1995), 93–5; A. E. Gallatin, *The Portraits and Caricatures of James McNeill Whistler: An Iconography* (London, 1913), 12–13, 37, no. 116, repro. in group of pls. following 39; A. E. Gallatin, *Portraits of Whistler: A Criticism and an Iconography* (New York, 1918), 18, 53, no. 138, repro. in group of pls. following 44; Martin Hutner, *Whistleriana: Works by and about James McNeill Whistler from the Collection of Martin Hutner* (New York, 2003), 25–26; Kilmurray, 221

Oscar Wilde (1854-1900)
Oscar
color lithograph, 1884
by Ape [Carlo Pellegrini] (1839-1889)
from *Vanity Fair* (24 May 1884)
34.9 × 22.5 cm. (13.75 × 9 in.)
signed "Ape" in plate lower right, magazine title and date printed above image, title and imprint "Vincent Brooks, Day & Son, Lith.," below

ACQUIRED: July 1984 from Holleyman and Treacher, Brighton, Sussex

EXHIBITED: Charlottesville, VA 1985, no. 118; Princeton, NJ 1995, no. 5; New York 2001-2002; Newark, DE 2002

LITERATURE: Cadden and Jensen, 11, no. 5; Kilmurray, 222; Roy T. Matthews and Peter Mellini, *In "Vanity Fair"* (London, 1982), 104, 228, repro. 105; Jerold Savoy and Patricia Marks, *The Smiling Muse: Victorians in the Comic Press* (Philadelphia, 1985), 167, repro. fig. 134; Stetz and Samuels Lasner, *England in the 1880s*, 66. no. 118, repro. pl. 16

Oscar Wilde (1854-1900)
pencil, ink and watercolor, [ca. 1894-1900]
by Sir Max Beerbohm (1872-1956)
32.4 × 20.3 cm. (12.75 × 8 in.)
signed "Max" upper right

PROVENANCE: Reginald Turner; Valuable Printed Books, Autograph Letters & Historical Documents, etc. . . . The Property of the Late Reginald Turner . . . , Sotheby and Co., London, 24-25 July 1939, part of no. 516; C. and A. Stonehill, New Haven, CT. Acquired: August 2000 from Franklin Gilliam Rare Books, Charlottesville, VA

EXHIBITED: New York 2001-2002; Newark, DE 2002;

New York and Chestnut Hill, MA 2005

LITERATURE: Bilski and Braun, 51, repro. 53

Oscar Wilde (1854-1900)
lithograph
by C. R.
caricature, front cover of sheet music, *The Oscar Wilde Galop*, Arr. Snow [J. Albert Snow?] [New York, ca. 1882]

EXHIBITED: New York 2001-2002; Newark, DE 2002

LITERATURE: Merlin Holland, *The Wilde Album* (London: Fourth Estate, 1997), repro. 99

W. B. [William Butler] Yeats (1865-1939)
lithograph, [1898]
by Sir William Rothenstein (1872-1945)
from William Rothenstein, *Liber Juniorum: Six Lithographed Drawings* (London, 1899)
31.7 × 28.6 cm. (12.5 × 11.25 in.)
signed and dated in the stone lower left

PROVENANCE: Redcliffe and Nina Davis Salaman (*Liber Juniorum* presented by Rothenstein, June 1904; Old Master, 19th and 20th Century, and Contemporary Prints, Sotheby's, London, 25 March 1998, no. 76. Acquired: February 1999 from Thomas Goldwasser Rare Books, San Francisco

EXHIBITED: Newark, DE 2002

LITERATURE: Davies, 120; Rothenstein, *Portrait Drawings*, 100, no. 90, repro. pl. 29; Rothenstein, *Men and Memories*, 330, repro. pl. facing 335

Living English Poets
caricature by Walter Crane (1845-1915)
reproduced as frontispiece in *Living English Poets MDCCCLXXXII* (London, 1883)
with portraits of *Robert Browning* (1812-1889), *Matthew Arnold* (1822–1888), *William Morris* (1834–1896), *Algernon Charles Swinburne* (1837–1909), and *Alfred, Lord Tennyson* (1809–1892)

PROVENANCE: Christina G. Rossetti (with inscription "W. M. Rossetti from Christina's books 1894"); William Michael Rossetti; Jerome Kern; The Library of Jerome Kern: Part Two, J–Z, Anderson Galleries, New York, 21–24 January 1929, no. 100. Acquired: Fine Books and Manuscripts, Sotheby's, New York, 11 December 1984, no. 666, via David J. Holmes Autographs, Hamilton, NY

EXHIBITED: Charlottesville, VA 1985, no. 89; Newark, DE 2002

LITERATURE: Walter Crane, *An Artist's Reminiscences* (London, 1907), 249, repro. 250; Gertrude C. E. Massé, *A Bibliography of First Editions of Books Illustrated by*

Walter Crane (London, 1923), 33–34; *The Letters of Christina Rossetti, Vol. 3, 1882–1886*, ed. Antony H. Harrison (Charlottesville, VA, 2000), 78–79; Jerold Savoy and Patricia Marks, *The Smiling Muse: Victorians in the Comic Press* (Philadelphia, 1985), 109, repro. fig. 94b; Stetz and Samuels Lasner, *England in the 1880s*, 49–51, no. 89, repro. pl. 12

Cope's Christmas Card, December 1883
watercolor, 1883
by George Pipeshanks [John Wallace] (fl.1880–1895)
44.5 × 55.9 cm. (17.5 × 22 in.)
signed and dated 1883 lower right
PROVENANCE: Allan Cuthbertson. Acquired: The Allan Cuthbertson Collection of Caricature and Humorous Illustration, Bonhams, London, 4 October 2000, no. 834, via Bertram Rota, London

EXHIBITED: *English Caricature, 1620 to the Present: Caricaturists and Satirists, Their Art, Their Purpose and Influence*, Yale Center for British Art, New Haven; Library of Congress, Washington, DC; National Gallery of Canada, Ottawa; Victoria and Albert Museum, London, 1984–85, no. 170; Newark, DE 2002

LITERATURE: Eric Denker, *In Pursuit of the Butterfly: Portraits of James McNeill Whistler* (Washington, DC, 1995), 79–80, repro. 80; Victoria and Albert Museum, *English Caricature, 1620 to the Present: Caricaturists and Satirists, Their Art, Their Purpose and Influence* (London, 1984), 115–16, no. 170, repro. pl. xxi

INDEX